Conservation
PHOTOGRAPHY HANDBOOK
How to Save the World One Photo at a Time, 2nd Ed.

Boyd Norton

AMHERST MEDIA, INC. ■ BUFFALO, NY

PRO PHOTO SERIES

Published by:
Amherst Media, Inc.
PO BOX 538
Buffalo, NY 14213
www.AmherstMedia.com

Publisher: Craig Alesse
Associate Publisher: Katie Kiss
Senior Editor/Production Manager: Barbara A. Lynch-Johnt
Senior Contributing Editor: Michelle Perkins
Editor: Beth Alesse
Acquisitions Editor: Harvey Goldstein
Editorial Assistance from: Carey A. Miller, Roy Bakos, Jen Sexton-Riley, Rebecca Rudell
Business Manager: Sarah Loder
Marketing Associate: Tonya Flickinger

ISBN-13: 978-1-68203-426-2
Library of Congress Control Number: 2019957390
Printed in the United States of America
10 9 8 7 6 5 4 3 2 1

AUTHOR YOUR iPHONE BOOK WITH AMHERST MEDIA

Are you an accomplished iPhone photographer? Publish your print book with Amherst Media and share your images worldwide. Our experienced team makes it easy and rewarding for each book sold and at no cost to you. Email submissions: craigalesse@gmail.com.

www.facebook.com/AmherstMediaInc
www.youtube.com/AmherstMedia
www.twitter.com/AmherstMedia
www.instagram.com/amherstmediaphotobooks

Contents

About the Author

Boyd Norton describes himself as a "recovering nuclear physicist." As a researcher for the Atomic Energy Commission in Idaho, he once blew up a nuclear reactor as a test. While residing in Idaho, he led several successful battles to save threatened wilderness using his photography. For the past five decades, he has been a freelance photographer and writer specializing in global environmental issues.

He is the photographer and author of 17 books, ranging in topics from African elephants to mountain gorillas, and from Siberia's Lake Baikal to the Serengeti ecosystem. His past books have won numerous awards and accolades. He is at work on three more books.

In 2015, he was selected as the recipient of the Sierra Club's prestigious Ansel Adams Award, which honors an individual who has made superlative use of still photography to further conservation causes over a lifetime.

Norton's photos and articles have appeared in most major magazines, including *Time, National Geographic, Smithsonian, Natural History, Outside, The New York Times, Audubon,* and many others in North America and Europe.

Throughout his 50 years of photography, writing, and environmental activism, he has played a key role in the establishment of several wilderness areas in the Rocky Mountain region, new national parks in Alaska, and in the designation of Siberia's Lake Baikal as a World Heritage Site. He has testified before numerous U.S. Senate and House hearings on wilderness and national park legislation. In 1991, he met with Russia's foreign minister in the Kremlin to lobby for the protection of Lake Baikal.

He is currently leading the battle to save the Serengeti ecosystem from proposed damaging developments. He has been documenting the Serengeti for over 30 years, leading photo safaris and on book and magazine assignments.

He received an award in 1980 from the Environmental Protection Agency, presented by Robert Redford, for his "important, exciting environmental photography and writing."

He is a founder and Fellow of the International League of Conservation Photographers and a founder and Fellow of the International League of Conservation Writers. He has also served on the Board of Trustees of the Dian Fossey Gorilla Fund.

Boyd describes this book as "a call to action, providing the tools and encouragement to become a conservation photographer and to help you save wilderness and wildlife everywhere."

Dedication

To my daughter, Jean Anne Norton, a ray of sunshine in my life and a fine photographer in her own right. She is carrying on the family conservation tradition in her adopted country, England, fighting to save Watership Down, the place in the best-selling book of the same name, and trying to stop a destructive highway through a lovely national park near her home in Arundel.

Acknowledgments

First and foremost, my thanks to my wife, Barbara, for her help and research, both of which were vital to this book. A special thanks goes to the several conservation photographers who very kindly contributed photos and words about their conservation work: Amy Gulick, Alison M. Jones, Joe Riis, Ian Michler, Katherine Feng (Wenzhen), Clay Bolt, Dave Showalter, Wendy Shattil and, sadly, to Wendy's partner, the late Bob Rozinski.

A big thank you to Odalys Muñoz Gonzalez for use of her award-winning polar bear photograph. Thanks to Jim and Cindy Griggs for their contribution of photos from the Maxwell Wildlife Refuge that they work so hard to protect. Another big thanks to Scott Trageser, an up-and-coming conservation photographer, for the use of his photo and words about a conservation issue that threatens many species around the world.

I'd like to thank the folks at Amherst Media: Barbara Lynch-Johnt, Katie Kiss, and Craig Alesse, for their faith in the project—and their patience. Final thanks goes to my agent, Peter Beren, for his great input in the early stages of the first edition.

Foreword

When I first came to the Sierra Club, one fringe benefit I hadn't anticipated was the art. In the hallways, the offices, and the conference rooms hang spectacular photographs (and a few paintings) that not only inspire us daily but also remind us why we come to work. Many of the photographs are the work of past winners of the Ansel Adams Award for Conservation Photography, which the club has presented annually since 1971. Some of the most spectacular are by Adams himself. We don't make a big deal about them, but perhaps we should. Once, during a meeting, a volunteer leader pulled *Clearing Winter Storm, Yosemite National Park* off the wall so he could tape pages of brainstorming notes from an easel pad to the wall. I suspect that kind of thing doesn't happen at the Philadelphia Museum of Art.

Photography has always been important to the Sierra Club, beginning with our founder. From the beginning, John Muir understood that people would care more about protecting places they had seen. He believed that if everyone in America could experience the mountains and valleys of his beloved Sierra Nevada for themselves, then the conservation battle would be won. Clearly, though, that would be impractical. Fortunately, there was an alternative: illustrations and photographs (along with

Muir's own impassioned prose) could bring the mountains to the people.

Little-known fact: Muir himself carried a camera on some of his later travels, though the results were not impressive. As a photographer, he was apparently a very good writer.

Luckily, from its earliest days, the Sierra Club attracted many talented photographers. At first, they simply documented club outings—both the enthusiastic participants and the spectacular destinations. Often, the club's annual weeks-long summer outing would include an "official" photographer, perhaps someone who might not otherwise be able to afford the cost of the trip. In 1928, one such participant was a young man named Ansel Adams. The photographs he made in the Canadian Rockies that summer were finally collected in book form 84 years later. Though Adams had no way of knowing it at the time, his photos documented glaciers that have since retreated by as much as a mile because of climate change.

Although earlier photographers had made nature and landscape images that furthered the cause of conservation, Adams developed a technical mastery and artistic vision far beyond his predecessors. Over the decades, he also evolved into a dedicated conservationist who served on the Sierra Club's board of directors for 37 years. Although Adams remained first and foremost an artist, he was more than willing to put his images to use in the cause of protection. *This Is the American Earth,* his collaboration with writer Nancy Newhall, launched the influential Exhibit Format Series of Sierra Club Books (the brainchild of the great David Brower). The series also featured talented artists such as Philip Hyde and Eliot Porter. Their photos and the accompanying text powerfully advocated for threatened natural treasures from old-growth redwoods to desert canyons. Not every fight was won, but without the work of these committed photographers, so much more would have been lost.

Whether Adams, Hyde, and Porter were conservationists who turned to photography or photographers who turned to conservation is beside the point. What matters is that they brought their art and activism together to help save many of the spectacular places we still love to visit (and photograph) today. John Muir was right: firsthand knowledge of nature is a powerful motivation to protect it. Can someone make a truly great photograph of nature without such knowledge? Maybe, but I don't think it's possible to truly see and know the natural world and yet remain indifferent to its fate.

So get involved. The camera is only a tool. It's the photographer's eye that makes the image. This book, too, is filled with tools for using your photography to help protect our remaining wild places and wildlife, but it's your passion that can make a difference. Use it!

—Michael Brune
Executive Director, Sierra Club

Cameras for a Cause

"Conservation photography is about inspiring thoughtful action with the goal of achieving real and tangible conservation gains."—*Alexandra Garcia, Former Executive Director, International League of Conservation Photographers*

What is *conservation photography?* How does it differ from, say, plain old nature photography?

Part of the answer to both questions is *content.* Content is a big part of defining conservation photography. Whereas a nature photographer may strive to convey the beauty of a colorful flower in full bloom with a butterfly, a conservation photographer might depict that same scene with a bulldozer looming large in the photo and about to crush the flower.

Another important aspect that defines conservation photography is *how* the photos are used. A nature photographer may be satisfied to show pictures of nature's beauty and grandeur to friends, to post on social media, or to exhibit work in galleries. A *conservation photographer* will go beyond the passive display of images and seek out some active use of them to halt a danger or threat to the environment. This may also entail posts on social media or exhibits, but along with the photos goes a strong message urging others to take action to protect and preserve that bit of nature. Also, many conservation photographers are political activists, urging legislators to protect the threatened scenes in their photos. For example, while I was living in Idaho in the 1960s, I became actively involved in trying to stop a terribly

destructive dam project planned for the Snake River in Hells Canyon, the deepest gorge in North America. This canyon forms the border between Idaho and Oregon. It was called the High Mountain Sheep Dam, and it would have flooded the wonders of the canyon under hundreds of feet of water. At the time, very few people nationwide had ever heard of Hells Canyon. On some trips there I began to use my camera to document the wonders of the place and used the photos to convince people that it was worth saving. Eventually, I had an article and photo essay published in *Audubon* magazine and took those photos to Washington D.C., where I had set up a meeting with Bob Packwood, the newly elected senator from Oregon.

below. I use this photo in some presentations to illustrate what conservation photography is about. I emphasize that it is a *constructed image* and that I was not about to be run over, along with the flower and butterfly, by that bulldozer.

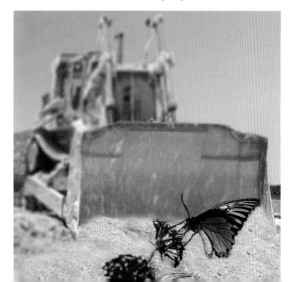

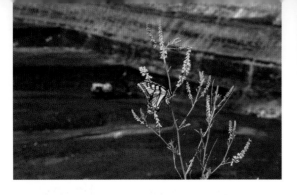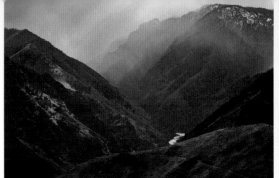

left. This photo is *not* a constructed image. It was actually taken on the edge of a huge open-pit coal mine in Wyoming, and that butterfly was clinging to the plant on the brink of the precipice.

right. One of my first photos of Hells Canyon, the deepest gorge in North America—7900 feet in depth.

I sat in Packwood's office and laid out on his desk those pages of gorgeously reproduced photographs of Hells Canyon. He silently looked at each page, slowly turning each to reveal the next. When the last page had been turned, he looked up with a perplexed look on his face and said, "Holy smoke. Is this in my state?"

In that moment, he became the champion in the U.S. Senate to preserve and protect Hells Canyon. Photographs did it. Packwood went on to introduce legislation to establish the Hells Canyon National Recreation Area and Wilderness. However, it took another seven years to accomplish that. There were numerous hearings, and I attended each one to testify and display photos of what we needed to protect.

So, a conservation photographer is also an activist. However, it is not necessary to chain yourself to a tree or lie in front of a bulldozer to express your activism. Instead, your photos can convince people that saving wildlife and habitat is important.

Photography and conservation have been linked closely almost since the invention of the camera. In the late 19th century, William Henry Jackson, Timothy O'Sullivan, Carleton Watkins, and other photographers contributed greatly to preserving public lands as national parks, national forests, wildlife refuges, and other preserves. The images they created raised public awareness about the beauty of special places and aided lawmakers in mandating protection.

Even in those earliest years of photography, at least two of those photographers mentioned were, unknowingly, *conservation photographers.* Watkins had shown his photos of Yosemite to prominent California politicians. His photographs of the grandeur of the valley prompted the U.S. Congress to pass legislation in 1864 to protect the valley, along with the adjacent grove of giant sequoias. Technically, Yosemite was not a national park because the protected lands were ceded to California as a state park. Nonetheless, we should credit Watkins as being possibly the first conservation photographer.

In the case of Jackson, when he returned to Washington D.C. after making his photos of the Yellowstone region on an expedition in 1871, he and the artist Thomas Moran displayed their works before Congress, convincing these politicians to establish Yellowstone as the world's first national park in 1872.

The mid-20th century became the Golden Era of photojournalism. Jackson,

Watkins, O'Sullivan, and other prominent photographers of late 19th century had been using the cumbersome wet-plate process for producing their photos. This process was slow and cumbersome, requiring the coating of glass plates on the spot, then developing the negatives made, also on the spot. Moreover, these plates were very insensitive and required long exposures for satisfactory results.

The ensuing decades saw rapid changes in both films and cameras. In 1913, Oskar Barnack, an engineer for the Leitz company in Germany, created the first 35mm camera, later hitting the market in 1925 as the famous Leica camera. Newer, faster films soon came on the market, along with smaller portable cameras, and photography became the tool for documenting our social and environmental world.

Through the early 20th century, those better films and easier-to-use cameras put photography in the hands of more and more people. Serious documentation continued, and by the middle of the 20th century, documentary photography blossomed.

Perhaps the greatest U.S. documentary photography project of all time was started by the Farm Security Administration (FSA) in the 1930s. It recorded the disastrous effects of drought and economic depression of that decade. Eleven photographers came to work on this project, many of them achieving fame through their images.

This was not a conservation photography program. Rather, it was intended to document the human condition and the poverty brought on by the depression. However, much of the work did include the environmental damage in the Dust Bowl and other regions ravaged by drought. In addition, many of the photos depicted landscapes in various parts of the country that serve to

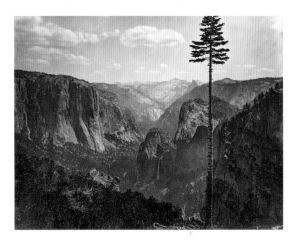

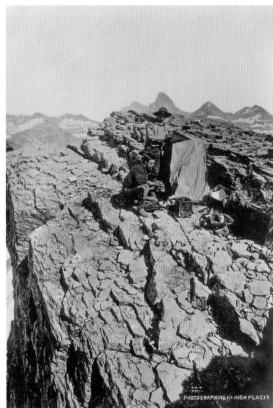

top. Carlton Watkins photographed Yosemite Valley in the early 1860s using the wet-plate process. His glass plate negatives were 18x22 inches in size! Public domain photo.

bottom. The equipment of William Henry Jackson consisted of all the chemicals and glass plates for producing photos using the wet-plate process. The tent served as a portable darkroom for coating the plate with emulsion and developing the image after exposure. This scene is in the Teton Range and is now a part of the Jedediah Smith Wilderness Area adjacent to Grand Teton National Park. Public domain photo.

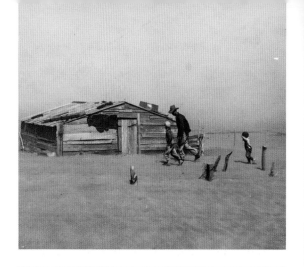

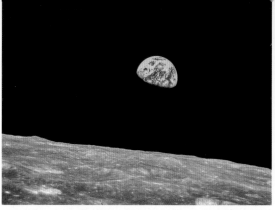

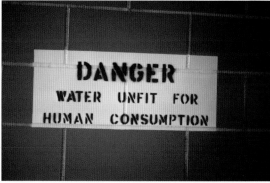

THIS IS THE AMERICAN EARTH

ANSEL ADAMS & NANCY NEWHALL

top left. Arthur Rothstein was one of the FSA photographers, and his best-known photo was this one, made in a dust storm in drought-stricken Oklahoma. Public domain photo.

bottom left. One of the first Sierra Club Exhibit Format books that was published featured Ansel Adams' exquisite black & white photographs.

top right. The photo made on Christmas Eve, 1968, by astronaut William Anders on the Apollo 8 mission around the moon.

bottom right. One of my early photos in the Documerica years. Taken in a restroom in Colorado Springs, CO. Photos like this may have provided incentive for passage of the 1972 passage of the Clean Water Act. In your own work, watch for signs like this that can help tell your story.

compare scenes today in those same places for environmental changes.

In the 1950s, picture-oriented magazines like *Life* and *Look* flourished, reaching millions of people through photo stories. In the post-war era, we became a more mobile nation. Visitation to national parks and national forests surged. More and more photo essays portraying the beauty of places like our national parks were published in popular magazines. At the same time, some growing threats to the environment were becoming topics of concern in the media.

Then came the 1960s. A 7000-member California hiking and mountaineering club, under the direction of a mountaineer named David Brower, began a dynamic renaissance in publishing. The organization

was the Sierra Club. Among the first of these large and lavish books was *This is the American Earth* by Ansel Adams who, at the time, had not yet become a household name. Others followed soon after, featuring the photography of Eliot Porter, Philip Hyde, and others. Some of these Exhibit Format books were devoted to specific battles to save such places as the Grand Canyon from dams and the redwoods from rampant logging. Others heralded the beauty of nature and our need to protect wilderness. This was accomplished by artistically combining spectacular photography with poetic quotations from eloquent nature writers. The genius of David Brower, through these magnificent books, is now credited with kick-starting the modern-day environmental movement. By the end of the decade, the Sierra Club membership had increased ten-fold, and the American public was responding to environmental threats as never before.

I was one of those greatly influenced by the Sierra Club books. The work of Adams, Porter, Hyde, and others made me realize how powerful a photo could be in rallying the public to effect change. Perhaps the photograph of that decade that had greatest impact in raising awareness of our fragile environment was not made by any of those photographers mentioned. Instead, it was the now-famous photo made on Christmas Eve 1968 by astronaut William Anders on the Apollo 8 mission around the moon—the first such mission made by humans. From the instant it was first shown publicly, *Earthrise* became symbolic of the need to protect the air, water, and land of our fragile spaceship sailing in the dark void of infinite space and juxtaposed against the barren, lifeless surface of the moon. Its content has made it a conservation photograph of the first magnitude.

Documerica

In 1972, at the establishment of the Environmental Protection Agency, another visionary program was started, this one to document, and serve as a benchmark of, the state of the American environment. The first head of the EPA, William Ruckelshaus, recognized the value of photography in capturing the essence of environmental issues of the time. He wrote, "It is important that we document that change [in the environment] so future generations will understand our successes and our failures."

It was called Project Documerica, and it was modeled after the FSA program. In fact, the chief advisor who was instrumental in establishing Documerica was the famed photographer Arthur Rothstein, one of the better-known FSA photographers. I was selected as one of the 50 photographers to participate in the program. Our task over the next few years was to document the state of the environment in America—the good, the bad, and the ugly. Some Documerica photographers lived in heavily populated and industrialized regions of the country. Many recorded serious air and water pollution problems of the time. Some, like me, lived in a relatively unspoiled region—the Rocky Mountains. At first, I chose to portray some of the beauty of the Rocky Mountain West. However, as time went by and as I traveled throughout the region, I became aware that places here were experiencing more and more destructive impacts from mining,

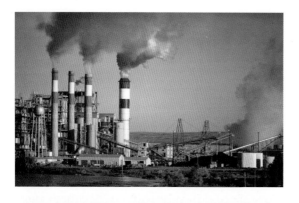

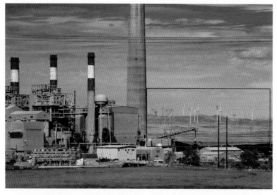

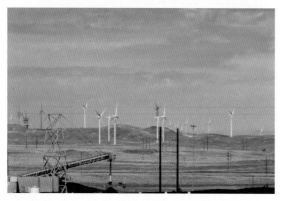

above. **Having spent so much time as a nature photographer capturing beauty, it was difficult, at first, to show some of the damaging things being done in the region.**

top. **I photographed this coal-fired power plant in Wyoming in the early 1970s as part of my work for Project Documerica. Air pollution standards had not been put in place at that time.**

center. **I recently revisited the power plant. It still generates electricity by burning coal, but now, due to EPA regulations, it has in place "scrubbers" to minimize air pollution. Note that in the background, there is now a large wind farm that produces clean electricity.**

bottom. **Documerica funding was halted in 1977. Industrial polluters lobbied to cease funding for the program.**

logging, dam building, and industrialization. It then became important for me to document the bad and the ugly.

Having spent so much time as a nature photographer capturing beauty, it was difficult, at first, to show some of the damaging things being done in the region. What I had to learn was *documentary photography,* the art of dispassionately and accurately capturing significant events and subjects and everyday life, especially as they related to the environment. I spent a good deal of time studying the work of W. Eugene Smith, Henri Cartier-Bresson, Gordon Parks, Grey Villet, and other greats. Of course, I studied the FSA photographers in order to gain insight into this specialty, too.

Because Project Documerica was a government-funded program, all photographs were in public domain and could be used freely by magazines, newspapers, and other entities. As the files grew in size, many of the photos were used to portray growing concerns over environmental degradation. One of my Documerica images—an aerial photo of a Montana strip mine illustrating the devastation caused by such mines—was published in *Time* magazine.

Equipment Choices

"It matters little how much equipment we use; it matters much that we be masters of all we do use."—*Sam Abell, National Geographic photographer*

That historic photo of Earth made from Apollo 8 was shot with a Hasselblad medium-format film camera. So what equipment do you need to become a conservation photographer?

Not much, it turns out. These days, your smartphone or a point & shoot camera will do. The main objective is to create images of and about your environment that have significant impact and may help to tell a story. Hopefully, then, that story will motivate action to achieve a conservation goal.

In the first edition of this book, I discussed at length various options for equipment to document conservation issues. These ranged from smartphones to point & shoot (PS) cameras to high-end digital single lens reflexes (DSLRs) and high-end mirrorless cameras (DSLMs). The problem with discussing various pieces of equipment is that this is a rapidly changing technology. What I write about today will be replaced by something newer, bigger, and better by the time this book is published; in fact, things will have changed next week, or even tomorrow. So I will limit myself here to discussing, in general terms, some of the features of modern digital cameras and dwell in more detail on what features may be most useful for achieving a goal. Some of you reading this book may already have the equipment of your choice.

Forgive me if I offer information here that might help someone just starting out.

Sensors

All digital cameras have sensors—semiconductor chips with an array of millions of tiny pixels that convert photons of light into electrical signals that ultimately produce, via processing, a digital image. That's the simple description, and it is not necessary to delve any further into the complex intricacies of the process. What is more important is some understanding of sizes and differences between sensors and what they may mean—or may not mean—for your photographic efforts.

Size. There's physical size of the sensor and there is the size in megapixels of the image produced by the sensor. A so-called full-frame sensor is the same physical size as the traditional 35mm film format—36x24 millimeters. (There are some medium format digital cameras with sensors larger than 35mm.) One would think that the full-frame size always gives the most megapixels. That's not necessarily the case. The megapixel count varies greatly, from 20MP to 60MP for certain full frame cameras.

There are other sensors of smaller sizes: the APS-C 22.5x15mm, the micro four thirds 17.2 x13mm, Foveon 20.7x

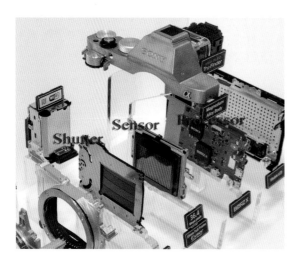

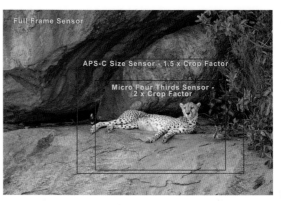

above. This shows the crop factors for an APS-C sized sensor and a micro four-thirds sensor. The red areas denote the equivalent crop of the scene taken from the same place with the same lens. In other words, a 100mm lens will appear to be equivalent to a 150mm lens on certain cameras with an APS-C sized sensor. For micro four-thirds, the crop factor is 2, and the 100mm lens becomes a 200mm equivalent. That crop factor is very nice when using telephotos or telephoto zoom lenses for wildlife. A 100–400mm zoom becomes the equivalent of a 150–600mm full-frame lens. However, that crop factor is a disadvantage when using wide or ultra-wide lenses and, in fact, many camera manufacturers designed special wide-angle lenses for APS sensors to overcome this drawback. (These cannot be used on full-frame cameras because severe vignetting will result.) So, if you use your favorite 20mm ultra-wide angle lens on a smaller APS-C sensor camera, the 1.5 crop factor will make it the equivalent of a 30mm lens—not so ultra-wide. I have a special 10–22mm zoom, which gives me the equivalent (with crop factor) of a 15–33mm lens full frame. The 15mm focal length is very nice for achieving certain ultra-wide angle effects (more on that later).

13.8mm. Some of these now equal and even surpass in megapixels the larger sensors on some cameras. Case in point: the Olympus OM-D EM1 Mark II has a micro four-thirds sensor but creates 20MP images—the same as the Nikon D5 full-frame camera. The takeaway here is: stay tuned. Advancing technology is improving sensors, and you should do some research to find the optimal camera for your work.

You may be aware that there seems to be a megapixel war in progress among camera makers. More is better, it seems. But is it? My first digital camera many years ago was a 6.3MP Canon 10D. That seems puny by today's standards, and yet numerous photos made with that camera have been published in books and magazines. (At least six of the photos in the first edition of *Conservation Photography Handbook* were made with that 6.3MP camera.) Now, by comparison, my Samsung smartphone has a 12MP camera.

Do you need more megapixels? Maybe. It depends on how you plan to use your photos. For publication in books and many magazines, images should have at least 300 pixels per inch (ppi) at the size they will be printed. The formula is simple: divide the number of pixels of the longest dimension of the image by 300 and that will give you, in inches, the largest size the image should be printed. My 6.3MP camera created

images that were 3072x2048 pixels. Divide 3072 by 300 and you get 10.24 inches—the largest size (longest dimension) on a page that the image can be used for good quality. Likewise, my 12MP smartphone creates images 4032x3024 pixels. Using the above formula, those images could be printed at 13 inches—more than enough for all but the very largest coffee-table book.

There may be other factors at work here: camera or subject movement that degrades the image or less than optimal lens quality. In addition, you may need to crop certain images because the main subject or object was too far away for the lens used. With large-megapixel cameras, you have more leeway to crop images and still maintain good quality for reproduction.

JPEG or RAW?

Let's keep this simple. A JPEG image is a compressed file, and a Raw image is a file

top. Rocky Mountain bighorn sheep photographed with a 50MP camera and a 400mm lens.

bottom. The above photo was severely cropped (red rectangle) to illustrate how images made with high-megapixel sensors may allow for extreme cropping. It would not allow for very large prints, but such cropping could be useful for researchers studying, for example, signs of disease or injury in a species without the need for tranquilizing or use of enormous lenses.

top. This photo of the Milky Way above Absaroka Ranch in Wyoming used an ISO of 6400 and a 30-second exposure. The lens was a 10mm ultra wide; used on a camera with an APC-S sensor, there was a 1.5 multiplier, giving an effective 15mm—still a very wide angle. A higher ISO—up to 12,400—would have yielded a shorter exposure, but the higher ISO would have created greater noise in the image.

bottom. A martial eagle takes flight from a perch in an acacia tree in Serengeti National Park. Shots of birds in flight and fast-moving animals are easier with the fast- and follow-focus system built into cameras and lenses these days.

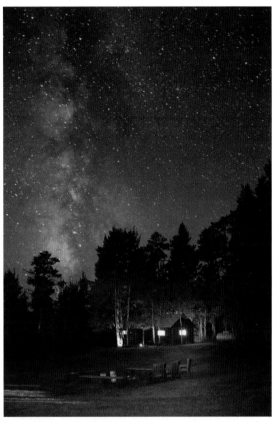

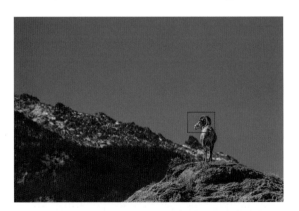

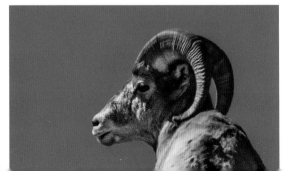

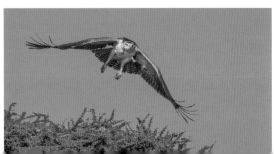

basically right from the sensor with lots of nuances of information. JPEG are smaller files, Raw files are large files. JPEGs have a bit depth of 8, which translates to a tonal range of 256 tones—sufficient for reasonably good quality of reproduction for many uses. A Raw file usually is 24 bits, which translates to a tonal range of 16.7 million tones. Obviously, Raw files are essential for fine tuning, in postprocessing, a wide gamut of color and tonal values.

Many, if not most, cameras these days allow you to create both a Raw and JPEG image when you shoot. Being small, the JPEG can be emailed and used quickly. The Raw can be postprocessed for fine-tuned images.

If you have to choose, then choose Raw; you can make a JPEG later from a Raw file.

Helpful Features

High ISO Range. This is a feature that was never available in the olden days when shooting film. With film, we were limited to speeds up to about ASA (ISO) 1600, sometimes more when pushed and which produced very grainy, low-quality images. Many digital cameras today are capable of shooting at incredible ISO settings—up to 25,000—and some boast an astonishing ISO of 400,000. These allow shooting under dim lighting conditions that were never possible with even the highest-speed films available. But there's a downside—sensor noise—which is somewhat akin to larger grain in the old faster films. Sensor technology is getting better in this regard, but noise is still present at extreme ISOs. This can be mitigated to some degree in post-processing, though it's not perfect—yet. Nevertheless, this feature can make it

possible to capture conservation images of importance under very dim lighting.

Lens Versatility and Quality. Things keep getting better. There are some digital Point & shoot cameras with zoom lenses having an amazing range. The Panasonic Lumix DCZS80, a 20MP camera, has a built-in zoom lens with a range from 24mm wide angle to 720mm super telephoto. It's not much larger than a smartphone and weighs less than a pound. By the time you read this, that camera and others will be even better and more versatile. These features help make it easier to keep a camera with you at all times, which would be unlikely with bigger, heavier DSLRs.

Micro Four Thirds (MFT). With the improvements made to sensors, it is possible to get very high-quality images from smaller sensors. In addition, eliminating the mirror and solid glass pentaprism in SLRs and DSLRs has made it possible to build quality mirrorless camera systems that are smaller and lighter than ever. Instead of reflex viewing by way of the mirror and pentaprism, these cameras have electronic viewfinders, in addition to the usual LCD screen on the back. Some of these cameras are also packed with other features discussed here. I know of at least one photographer who shoots regularly for *National Geographic* who uses an Olympus MFT camera and lenses. For anyone who travels long distances by air these days, the smaller and lighter equipment is a blessing; I can attest to this as one who has dealt with airline restrictions, excess baggage fees, and TSA security hassles.

Sophisticated Auto-focusing Mechanisms. These also keep getting better. If

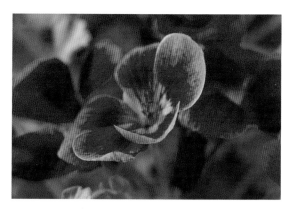 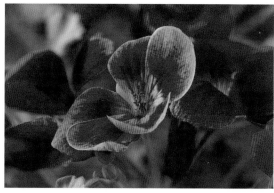

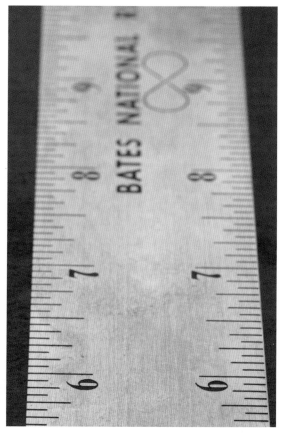 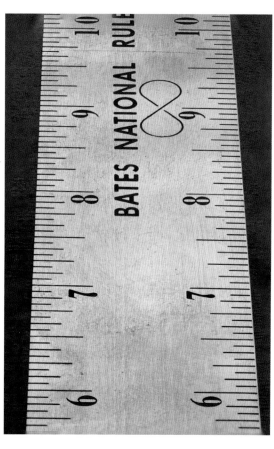

top left and right. In this close-up photo of a flower *(left)*, the shallow depth of field allowed only the very front edge of the petals to be in focus. The second photo *(right)* was done using focus stacking. Combining four images, each with a separate focus, resulted in nearly overall sharpness of the flower.

bottom left and right. A more graphic illustration that shows the usefulness of focus stacking. In the right photo, 16 separate exposures were made at f/4. In each shot, the focus was changed slightly (about $\frac{1}{4}$ inch) from 6 to 10 inches. These photos were then combined in Photoshop to give this incredible degree of sharpness from 6 to 10 on the ruler. This wouldbe difficult for moving subjects unless they were slow-moving.

you are specializing in wildlife action and behavior, you might add some of these features to your checklist for a new camera. These include very precise focusing for following moving subjects—birds in flight, fast-running animals.

Focus Stacking. This is a feature unique to digital photography. There are times, particularly in macro photography, when depth of field (keeping near and far objects in sharp focus) is very limited. Normally, stopping down the lens to a smaller aperture, f//11, f/16, or smaller, might help by increasing that depth of field. But often, especially when working in macro or close-up mode, smaller apertures may not help much. (Note that smaller apertures beyond f/11 may also degrade the image due to diffraction effects.) Here is where focus stacking is important. A succession of images are made, starting with focus on the nearest object, then changing the focus slightly to a spot farther away for each successive photo. These images are then combined, either in Photoshop or in-camera, to create a single photo that has incredible sharpness from foreground to background. This could be a very useful feature in your work—especially if you need to portray certain minutiae.

Image Stabilization (IS). This is vital when using long telephoto lenses, when shooting video, and when shooting under dim lighting conditions (slow shutter speeds). There are two kinds of IS: lens based and sensor based. In the former, the lens has sensors to detect horizontal and vertical movement and a lens element is moved to compensate. In the latter, the imaging sensor in the camera body is moved to compensate for vibration and shake.

These in-camera IS systems have the advantage of working with lenses without built-in IS. Some cameras have both systems. Image stabilization has greatly improved and will likely get even better. So if you are starting out or if you are upgrading to a new camera system, check 'em out.

Burst Modes (Frames per Second). This is useful for fast-moving action, allowing for continuous shooting to get just the right peak of action for a still image. Some cameras, such as the Olympus OM-D EM1 Mark II MFT will shoot an amazing 60 frames per second (with a fixed autofocus setting) at 20MP full-resolution Raw files. It will also shoot with continuous auto-focus at 18 frames per second (fps)—useful for fast-moving subjects. Other cameras may have similar frame speeds but may record only JPEGs. Raw files are obviously preferred for post-processing to full advantage. Again, check out this feature and decide how it best works for you.

Pre-Burst Mode. Some digital cameras now offer a pre-burst mode. This is ideal when you're unsure of the critical moment to press the shutter button. This will record 8MP images at 30fps one second prior to and one second after pressing the shutter button in order to give you 60 frames to choose from. Generally, these images are JPEGs, not RAW files.

HD or 4K Video. Any digital camera today, including your smartphone, has video recording capability. (See chapter 10 for more details on shooting and using video.) In brief, cameras with high-definition video (HD) record frames at 1920x1080 pixels in size and at 30fps (actually 29.97) for normal playback. 4K produces frames that are 4096x2160 pixels in size and at

similar frame rates (more detail in chapter 10). Video is an important component of your conservation photography. Even a short 3–5 minute video can, in a compelling way, convey to people the story of your battle to protect a place or save a threatened species. In addition, you can pull frames from a video sequence and use as a still photo in presentations and reproductions. An HD video frame is equivalent to a 2MP photo—not very large—but it can be surprisingly good if not used too large. A 4K video produces frames equivalent to an 8MP camera and are very useful for quality reproduction in books or magazines. By the time you read this, 4K may be the standard in most cameras.

Time lapse video recording is another useful feature. By recording at a rate of, say, one frame every minute, slow action like a growing plant is sped up and compelling when played at normal video speed. Many cameras have this capability.

WiFi. Built-in Wi-Fi and Bluetooth allow you to wirelessly share photos and movies to linked smartphones and tablets for direct sharing online. More importantly, this connectivity also allows you to remotely control the camera from a mobile device—a smartphone or a tablet.

GPS. Unfortunately, not all digital cameras today have GPS tagging built in. I suspect that, with all the other features crammed into cameras these days, the electronics for GPS may have taken up too much space. I think many of us will agree that GPS tagging of photos taken in certain places can be vital.

There are some options if your camera does not have GPS capability. First, some camera manufacturers have add-on units available. These plug into the camera body and record the coordinates in the metadata of each picture. Another option is to use your smartphone, take a photo alongside your regular camera, then input the GPS coordinates from the phone to the metadata for the image(s) in your computer.

Input/Output Ports. You may want to check the specs of the camera you're interested in to be sure there are USB and HDMI ports for transferring video and still photos from camera to computer. Most important for video shooting, be sure there's an input to plug in an external microphone (the built-in mikes in cameras are usually pretty bad and pick up too much extraneous noise). There should also be a port to

top. This dead lioness was photographed in a remote part of Serengeti National Park and was part of a pride of lions being studied by researchers. The camera I used recorded the precise GPS coordinates, and I sent those to the researchers so they could investigate the cause of death. There appeared to be a serious wound on the flank of the lion.

bottom. This add-on GPS unit plugs into the camera's hot shoe and puts GPS coordinates into the metadata of each photo made.

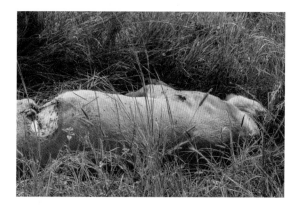

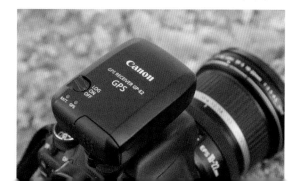

plug in headphones to monitor audio when recording video if the soundtrack is important, as when interviewing people.

I also carry a GoPro. It is a high-quality camera giving 12MP still photos and 1080P HD video. It is my all-weather and underwater camera of choice. For traveling light, it can't be beat. It features a wide-angle lens, and you can make some limited adjustments as to the angle of view. Current GoPro models have a small LCD screen to view the image. There is a GoPro app available for iOS, Android, and Windows smartphones that will give a live view via Wi-Fi and allow operation of the camera remotely. You can not only view live what the camera sees, but also change any of the many settings on the camera.

Drones

Some conservation photographers love them, some hate them. Even the latter will sometimes agree that they can be useful, perhaps even vital, for getting strong images that illustrate a conservation issue. I remain somewhat neutral on the subject.

The main issue with the use of drones is ethics. When used to record wildlife from the air above, many animals react to the sound. There have been instances of low-flying drones panicking animals— obvious harassment. I don't know that it will ever be possible to build a completely silent drone, but perhaps that should be a goal. Another issue involves use of them where restrictions are in place—over designated wilderness areas, and perhaps some national parks, for example. My advice: be aware of any restrictions about their use in places and keep the welfare of animal life foremost when using them.

The main objective here is to use the equipment that you have and to employ it effectively to create images with impact. Even your smartphone should be considered a part of your arsenal, because you may not always be traveling with all your sophisticated equipment. For times when you need to work quickly, a point & shoot camera may be the best choice. Sometimes the size and bulk of a DSLR and big lenses may attract attention when you don't need it. In other words, keep it simple and effective whenever possible.

Some final thoughts on equipment: Even the simplest cameras have evolved into sophisticated image recorders, with many features of great use. In DSLRs and DSLMs, there are a bewildering number of features. I often joke in my lectures and workshops that I used to run nuclear reactors that were less complicated than my digital cameras. But seriously, all these features are designed to give us a great array of creative options—bracketed exposures, time-lapse video, high-speed frame rates for fast action, HDR for extending latitude in high-contrast lighting, HD and 4K and higher video, focus stacking for increasing zonal sharpness, and much more. It is important that you familiarize yourself with many, if not most, of the features and learn how to use them. This is especially important when working in the field and you need to use some special feature. Fumbling around trying to turn on that feature may cause you to lose a good photo opportunity. Know your equipment well!

Light: Quantity, Quality & Direction

"Nature is so powerful, so strong. Capturing its essence is not easy—your work becomes a dance with light and the weather. It takes you to a place within yourself."

—*Annie Leibovitz*

The word *photography* comes from two Greek words: *photos,* meaning light, and *graphos,* meaning to write. When we write with light, we must create the strongest impact possible, much like the writer must carefully select words that make ideas and thoughts resonate with readers. Too often in the excitement of making a photograph, we overlook things like *direction* and *quality* of light. The *quantity* of light is equally important, for there are times when we may wish to deliberately overexpose or underexpose for effect or for certain corrections. You need to become a student of light, spending time analyzing its characteristics. Doing so can often mean the difference between an ordinary picture and one with greater impact.

As you study this chapter, you may want to have at hand certain of your photos in order to analyze them to see how a different kind of lighting might have been used to improve them. The illustrations I use here are just a starting point. Compare them to photos you have made under similar lighting.

There are many good books and online tutorials for using Photoshop, Lightroom, or ON1 PhotoRaw, so I will not get into detail here about their use. I encourage you to learn how to use these programs. They are powerful tools for organizing files and

left. Sometimes it is impossible to capture the subtle colors and lushness of a rain forest with sunlight streaming down through the foliage. Better to wait for overcast and softer lighting.

below. Here, the lighting is softer due to heavy overcast and pouring rain (they don't call it rain forest for nothing). The nuances of color and dense, lush growth are captured better here.

working with individual photos to achieve the best quality for them.

Quantity of Light

Back in the days of shooting film and before cameras came with internal light metering systems, we all used a hand-held light meter to determine exposure. However, simply pointing the meter at a scene would not produce the best, most precise exposure. You had to learn to interpret what the measurement meant. It could be a tricky process. If you weren't careful where you pointed it, brighter or darker areas would lead to under- or overexposed photos. For example, a bright field of snow would cause the meter to read all that brightness and give you a measurement that would lead to an underexposed photo. Why? All light metering systems are based on an averaging of bright and dark areas approximated by an 18 percent or "middle" gray. With the bright snow, the meter is telling you to make an exposure to give the snow a middle gray rendition. If you use that exposure, the white snow will be middle gray—underexposed. Similarly, if you pointed the meter at some dark shadows, it would result in overexposure in other parts of the picture. The meter would try to make those blacks a middle gray.

Today, the internal light metering systems built into our DSLRs, point & shoots, and even our smartphones do a very good job of giving us excellent exposures 99 percent of the time. Most, if not all, DSLRs and MSLRs use (often as a default setting) a sophisticated multi-zone metering system. Depending on the camera make, it's called *matrix metering* or *evaluative* or *segmented* metering. With it, various portions of the scene are analyzed for light intensity, and the results are combined in a processor with a database of thousands of exposures to compare. The result is amazingly accurate most of the time. I recommend using this multi-zone setting in your camera because it will give the best exposures in virtually all instances. The biggest advantage is that you can concentrate fully on the image in the viewfinder, and this is important. I disagree strongly with those who suggest that the only way to get proper exposure is to use the camera's manual setting. That may be fine if you have all the time in the world to fiddle with the exposure setting, but as a documentary photographer, you often have to work quickly.

What about the 1 percent of the time when you don't get the best exposure? This can happen in situations when there are extremes of light and dark areas in the same scene. A good example of this is a forest scene in which shafts of bright sunlight stream down among the trees. Parts of the forest floor are illuminated by sunlight, and other areas are in dark shadow. Exposing for the shadow areas will cause the bright areas to be blown out—way overexposed, with little or no detail in the highlights. Exposing for the bright areas will result in inky black shadows, again with little or no detail. Most multi-zone metering systems will compromise, giving an exposure that may have some overexposure and some underexposure in the image. Will that be sufficient? In other words, could the image be made usable by some manipulation in Lightroom or Photoshop? The answer is a definite maybe.

Another option when you are faced with these extremes of lighting is to bracket

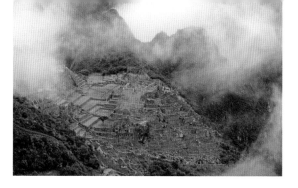
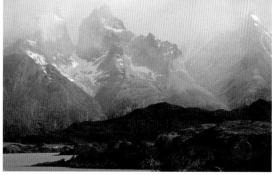

left. Many of my visits to Machu Picchu have been at times when it's sunny and bright, and I have gotten many shots of the Inca ruins in early morning and late afternoon. On this visit, it was cloudy and misty. I had hiked up to the Sun's Gate on the Inca Trail, and as I looked back down on the ruins, the clouds momentarily parted and I got this moody picture that imparts a sense of mystery. Serendipity. The mood it creates is far better than most of the other photos I have made here.

right. Mood. The mist and clouds breaking up over the peaks in Torres del Paine National Park in Chile impart a sense of mystery.

left. This photo was made with the camera's Auto white balance setting. It's subtle, but some of the color was lost when AWB compensated for what appeared to be too much color shift.

right. In this photo, the white balance mode was set to Daylight, and the camera did not try to compensate for color shift. Keep in mind that AWB tries to adjust for what it perceives to be a color cast caused by different color temperatures light; for scenes such as this, you want to capture that color.

your exposures. On most DSLRs and DSLMs, you can do this via a menu setting. The camera will fire three or more shots rapidly, each at a different under- and overexposure setting. You can later use high dynamic range (HDR) techniques to combine your files into a single photograph with a wide range of exposures optimized to give good detail.

A word of caution: be careful when using HDR. I've seen some examples so extreme as to be bizarre or surreal; that might be counterproductive to your conservation goals. Keep it real.

Quality of Light, Mood & White Balance

We've all experienced a time when light has a magical quality. It may be early morning or late in the day when everything is bathed in warm light, or when the sun breaks through the clouds and illuminates a subject in a special way. It is hard to define, but you know it when it happens. It is completely unpredictable. So, how do you capture it? F/8 and be there!

Being there, however, doesn't always guarantee that you will capture that magic lighting. White balance can get in your

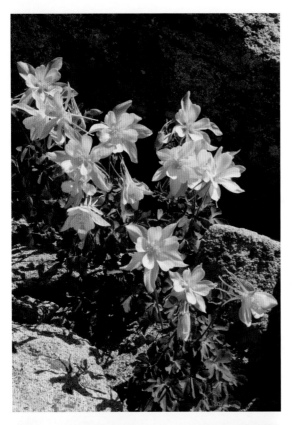

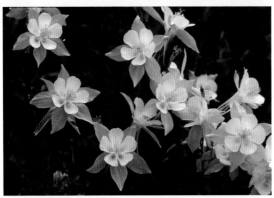

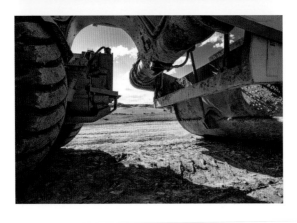

way. Think of it this way: the color of light outdoors varies with time of day; indoors, it changes based on the light source. Outdoor light color can also vary with elevation. In high mountain country, above 5000 feet, there is a stronger blue component in the light, even though we may not notice it. Why don't we see it? If the color of light is not too extreme, our eyes and brains quickly adapt to these changes, and we don't notice any color cast—or at least it is diminished. The camera's sensor does not adapt, so photos may have color casts depending on the light source.

The color of light is measured in degrees Kelvin (K). A color temperature of 5000 to 5500K is considered to be more or less neutral—neither warm nor cool. This is the color of light at midday in moderate latitudes. Any white object in your photo will be rendered white without any color cast. At a higher color temperature, say 9000K, that white object will have a blue cast. A color temperature of 3000K (most common for indoor lighting) is warmer, and whites will have a reddish or orange cast.

Digital cameras have modes or settings called *white balance* for compensating for the different lighting conditions you may encounter. Shooting indoors without flash, you can choose Indoor or Tungsten mode.

top. Compare these two photos of columbine flowers in the Colorado mountains. The first was taken in bright midday sunlight—very harsh lighting for something with subtle tones and colors.

center. This photo was made in the open shade under some large trees. Nuances of color come through in this softer lighting.

bottom. Bright, high-overhead, high-contrast sunlight imparts a harshness to this scene of a giant earth-moving machine about to engulf the soft rolling ranchlands beyond.

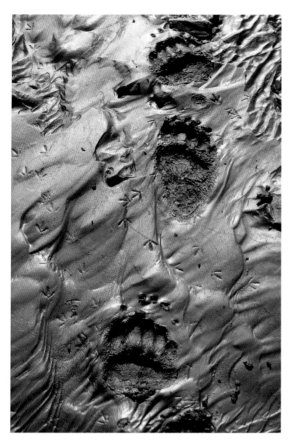

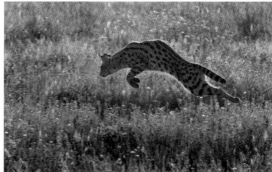

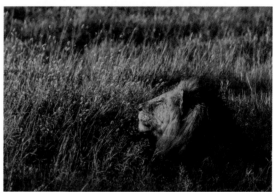

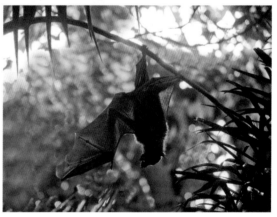

left. **Side lighting. Low-angle, early-morning light brought out the texture of these grizzly bear tracks in Gates of the Arctic National Park in northern Alaska.**

top right. **Backlighting on this pouncing serval cat in Serengeti National Park creates an ethereal glow of fur around the cat in midair.**

center right. **The warm glow of dawn sunlight on this male lion in the Serengeti imparts a special attractiveness to the subject.**

bottom right. **Backlighting on this fruit bat in Borneo shows the delicacy of the membranes of skin forming the wings.**

Because most interior lighting is 3000–3500K, or very warm light, the camera adds some blue to compensate and make whites more neutral.

Auto White Balance (AWB). For a certain amount of convenience, it is helpful to leave the camera's white balance setting on Auto. In most cameras, it works most of the time to correct for variations in a scene. However, when you are shooting that wonderful warm light of a sunrise or sunset, the auto white balance setting may compensate too much and remove some of that warmth and color. You can, of course, bring back that quality of light later by making adjustments in Photoshop or Lightroom.

The lesson here is, don't leave the camera setting on Auto white balance all the

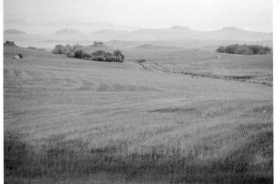

Why? Because the harshness of bright sunlight wipes out subtle colors, and the contrast between light and dark areas is so great that tonal nuances are lost.

Direction of Light

It used to be a rule of thumb for amateur photographers to take a picture with sunlight coming from "over the shoulder," illuminating the subject straight on. I suppose the reasoning was that this helped create more evenly lit subjects for simpler cameras to handle. However, front lighting can be flat and uninteresting, and, very often, harsh. In midday, with the sun directly overhead, this lighting may also create shadows under the eyes of people, which is very unflattering.

Now, having pointed out the sometimes harsh characteristics of bright sunlight and front lighting, bear in mind that as a conservation photographer, you may not *want* to use softer, more flattering light for certain subjects. The idea is to convey a feeling about a subject or place. The harshness of direct overhead sunlight on a large earth-mover generates a certain feeling about the destructive machine in comparison to the soft gentle ranchlands about to be dug up for an open-pit mine.

Side lighting creates dimension, sometimes drama. It also brings out texture and can give dimension to objects.

left. Mood. I underexposed this photo to create something ominous and threatening in the machine picking up coal in an open-pit strip mine in Montana. As part of a documentation of the ranchlands in Montana being threatened by more strip mines, I paired this photo with the next one.

right. Mood. In my documentation of Montana ranchers fighting to save their lands from strip mining, I recorded this scene of one of the ranches. A light, misty rain was falling. The lighting was subdued, but I overexposed slightly to create a more high-key photo. I placed the horizon high in the picture to give emphasis to the land in the foreground. Interestingly, the misty rain acted like a large diffusion filter, giving a painterly softness to the photograph. This made for a photograph that portrayed the quiet beauty of a fertile land and contrasts with the low key, ominous photo of the strip mine.

time. For those colorful sunsets or sunrises, the Daylight white balance setting is better for retaining the rich colors that Auto white balance would try to diminish.

What about overcast conditions? For subjects like flowers, foliage, and forests, soft overcast lighting is my preference.

Backlighting, though tricky, can create something ethereal or moody.

The quality of light can make or break an image. You can use the warm glow of early-morning sunlight to your advantage, or work with the softness of overcast light to bring out the delicacy and variations of the subtle colors of flowers.

When you are engaged in telling a visual story about a threatened place, photos that convey the varying moods of the location can help greatly in drawing people to your cause. Capture those various moods of the seasons and of weather in particular. Morning mists and fog covey a sense of mystery. Calm waters reflecting the last colors of dusk give a feeling of calm and tranquility. These things can engage your audience.

In photography, the terms *high key* and *low key* are used to define the kind of lighting in a picture that creates a mood or certain feeling. High-key images are light and associated with positive emotions— happiness, pleasurable experiences, an upbeat mood. Low-key images are dark, often representing something somber, dramatic, or ominous, though they can also represent something quiet.

These are important considerations to tell your conservation story effectively. Things to consider about lighting your scene or subject include:

- What kind of mood do you want to convey? Dark and ominous? Light and airy and uplifting? What's the best time of day to achieve that mood?
- What is the direction of the light on your scene or subject? How will this affect the mood or feeling you wish to create?
- What attributes of your scene or subject would benefit from changing lighting direction: texture, color, form, tone?
- Is the bright sunlight too harsh for the subject or scene? Would overcast lighting be better?
- Is the contrast range too much to correct or adjust later in Lightroom?

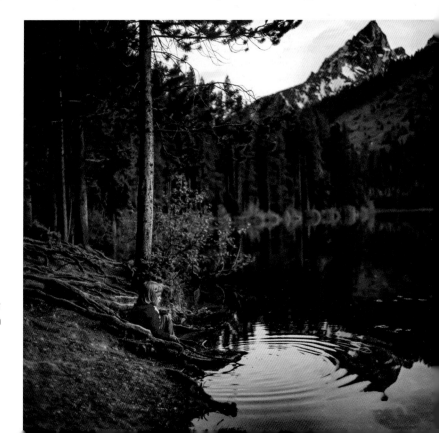

bottom right. Mood. A feeling of calm and tranquility in this scene at dusk as a child (my daughter at age 3) gently ripples the waters of a lake in Grand Teton National Park.

Challenges of Conservation Work in China

Photo credit: Huang Songhe.

Dr. Katherine Feng is a first-generation Chinese American who was born and raised on the east coast of the United States. Her love of nature and animals ultimately led to her first profession, a Doctor of Veterinary Medicine. A photo safari to Kenya in 1987 with me led Katherine to a second career as a photographer and tour leader. In 1992, she left her veterinary practice to devote her full energies to travel and photography.

Katherine wishes to use her images to show the world, especially the people of China, the unique natural heritage they possess and to encourage them to protect not only the animals, but the entire biodiversity of the habitat in which they live. She works closely with the Chinese State Forestry Bureau and the researchers within the nature reserves. Katherine's goal is to document as many of China's endangered animals as possible.

What distinguishes conservation photography from ordinary nature photography?
"While nature photography usually aims at showing the beauty, grandeur, and awe of a subject/subjects or place, conservation photography goes beyond that; it also focuses on real-life situations and gives value to wildlife and the environment. People want to save things that have value. That value may be the emotions evoked in people by images, importance to the welfare of populations, or the benefit it has to the environment. Conservation images need to be educational, while inspiring and motivating people to protect wildlife and their habitat. Threats, especially caused by people living in or near the habitat, can be portrayed by photos. Also, efforts and progress being made to protect and preserve need to be included in a conservation story. The last is important, as it gives people hope and a reason to take action."

Obviously, there should be focus on your work. What made you get involved?
"In 1996, I started leading photo tours

to Wolong Nature Reserve, where it was possible to take images of captive pandas in natural surroundings. Then, in 2002, I was given the unique opportunity to photographically document all the work being done at the China Conservation and Research Center for the Giant Panda (CCRCGP) in Wolong Nature Reserve to save the giant panda from extinction. I spent 6 to 9 months a year, for 4 1/2 years, in Wolong NR. Because I am also a veterinarian, I understood what needed to be photographed in addition to pretty panda photos. Images from this body of work have been published internationally. I want the world to know how hard the staff works and to recognize the successes of the giant panda rescue and breeding programs. It was because of work during this period that I was invited to join the prestigious International League of Conservation Photographers.

"Leaders from other Chinese nature reserves visited Wolong and, after learning of my efforts to protect China's wildlife, they invited me to visit and photograph work being done in their nature reserves.

"I have to admit that being a native English speaker has also been an advantage. Several times, I have helped researchers translate articles for publication and then, as an unexpected bonus, doors opened to more nature reserves.

"My grandfather, Feng Yuxiang, was a national Chinese hero, and the family name has helped me gain access to different nature reserves. It has also helped my conservation efforts when people of China learn the granddaughter of General Feng is involved in protecting China's wildlife and their habitat. It encourages them to do the same."

Tell me about what you have learned and why people should care about what you are working to save.

"With nearly 10 percent of all plant spe-

below. Adult panda in China's Wolong Nature Reserve. Photo credit: Katherine Feng.

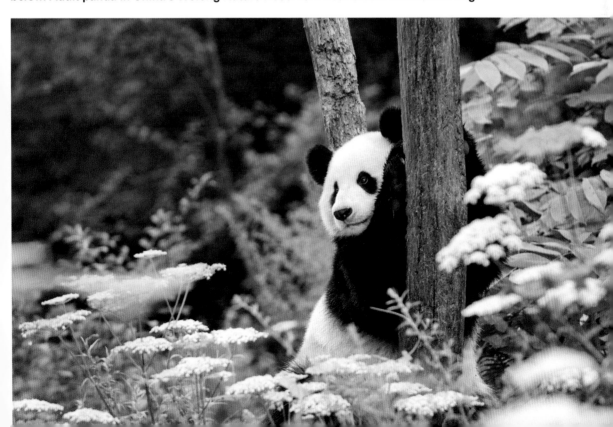

cies and 14 percent of the world's animal species, China is one of the 17 mega-biodiversity countries in the world. Biodiversity not only helps maintain the productivity of ecosystems, but also provides resources that are equally important to people. The rapid socio-economic development in China has put its biodiversity under increasing pressure.

"I focus primarily on China's endangered species so that the world will better know not only that these unique animals exist, but also the threats that are occurring. On a national level, I use my images to encourage the Chinese people to protect wildlife and their habitats. On a global level, I wish to show the world that China does recognize the importance of these animals and their habitat and is working hard to protect them. I have learned that it is mutually beneficial if people and wildlife can coexist. I feel that if wildlife is to be protected, we must also help the local people, so they do not increase their demands on the habitat. It is very important that the local people see a benefit, so that they will help conservation efforts."

Why should other photographers become involved in conservation?

"Photography is a strong tool. Images can show or create emotions much better than words could ever describe. They can also show pain and devastation better than words. With words, people need a verbal reference point to feel. With a photograph, whether it is about compassion or suffering, the reality of the situation is right in front of the viewer. Conservation advocates need to use all these kinds of images."

Do you think a good "ugly" photo has as much impact as a pleasing nature photograph? Certain photographs have great shock value. Many years ago, on a magazine assignment in East Africa, I photographed, up very close with a very wide-angle lens, a dead rhino with its horns cut off. The editor almost didn't use it for fear of shocking people too much. Your thoughts?

"I think one should definitely take the photograph, but I would use discretion on how it is used. Some people would be offended at the sight of such a picture and may not finish reading the article, but others might see the extent of the suffering animals experience at the hands of people and would want to put a stop to it.

"Editors are often unpredictable. After the 2008 Sichuan earthquake, I was asked to transport veterinary supplies for the giant pandas. The main road into Wolong no longer existed, so what would have been a three-hour drive before the earthquake entailed driving 14 hours over two high mountain passes (over 14,000 feet). While there, I was working with *National Geographic* to show the damage done by the earthquake. I took a picture of a giant panda named Mao Mao that was uncovered a month after the earthquake. The panda's head was black and decomposed (also very odiferous), and I never thought *National Geographic* would publish such a photo, but that was the one they decided to use in the article. In the end, I could understand their choice, as earthquakes are natural events that have always been associated with death and destruction. Even pandas were affected."

What problems and/or issues have you encountered in your work, and how did you deal with them?

"Of course, language is a barrier. I was born and raised in the United States. When I was 50 years old, I studied Chinese for three months in Beijing. I can now understand simple, basic Chinese. Beyond that, it can be very trying to understand what people are telling me, especially about what and why the animals are doing certain behaviors. I often have to depend on my knowledge from being a nature photographer and a veterinarian. Translations on today's smartphones help, but it is time-consuming. Sometimes when I speak Chinese, I say something entirely different than what I meant to say. Once, I wanted to ask an outstanding photographer if I could learn from him, and what I did was ask if I could sleep with him. At times like that, all you can do is laugh and hope the other person laughs with you.

"One thing I always try to remember is to not let anyone "lose face." That is so important in the Chinese culture. I try very hard not to ask for things or access when the leaders may say "no" as, being an important person, they will lose face. Nor do I correct them. I try to never say "you should"; rather, I ask, "have you thought about" or "I would try this." For the most part, I do not think the Chinese have been afforded the sensitivity and respect due to them.

"One also must be very careful with criticism. Foreigners often do not understand how leadership works, not only in China, but in many countries. If someone criticizes the government, often the local people are punished, even if they were forced to work with that person. Once, I asked a leader why he did not fight development more, and his answer was "If I fight too much, they will replace me, then who will fight for the animals and their habitat?" Know that even as I write this, I am very careful no one can be recognized. Just know that what you see does not always accurately reflect who makes the decisions and why they are made.

"Whatever I do reflects upon my family name and me, personally, as a foreigner, so I always try to do good and say positive things about the work being done by the directors, staff, and even the local people. Once, while working with a Chinese national on the poaching of raptors, the Chinese national told the news media that the local forest police were working very hard, but more people were needed. The government immediately dispatched more police. This was so much better and more effective than criticizing the government for not having more people in the first place. I find that people are more accepting of me if I put a positive slant on things and help try to find solutions rather than voice criticism. That works worldwide, not just in China."

Is there anything you would like to add?

"Be willing to share and help. If you are beginning to work in conservation, work with local organizations. While helping local issues, you will learn a lot and develop skills which may help you progress to larger projects and organizations if that is your goal.

"Develop relationships and trust with the government, leaders, fellow conservationists, and local people.

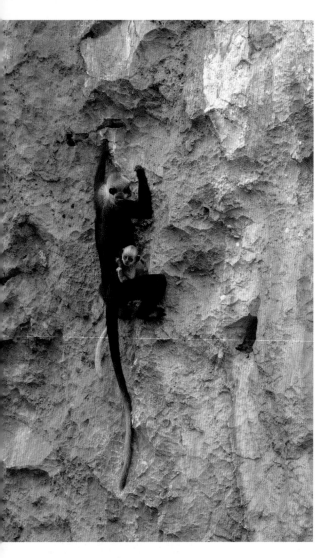

visitor by not harassing wildlife or destroying the environment. It is best to teach them by example. In one reserve, while waiting for a family of endangered gibbons to pass by, there were bushes blocking my view. The local ranger started to cut down the bushes. I stopped him, took out a long piece of nylon cord, tied the branches together, and pulled them out of my view by tying them to a nearby tree. He was shocked, as all previous photographers just cut down the plants. Education is so important!

"In the same reserve, there was a lot of litter along the trail. Everyday, on the return to the research station, I would pick up a few pieces of litter. Without saying a word, after a day or two, the rangers were also picking up litter. Teach by example!

"If and when you take photos of people's actions that may impact wildlife, habitat, and local people, do not include faces or identifying features. You do not want to get people in trouble, but rather, teach people good and bad behavior—and you should be taking these kind of photos.

"While money can be made doing conservation photography, conservation should be your main focus. Please, never lose sight of that mission!"

"If appropriate, donate images to help conservation, but protect them with your copyright and limit their use. While larger NGOs have the budget to purchase the right to use your images, in China, and I am sure other countries, the nature reserves often do not. Although I have rarely been paid for use of my images by nature reserves and researchers within China, I have helped raise thousands of dollars and other forms of support for their conservation and education efforts.

"Use your images to teach people how to behave in nature—how to be a good

Lenses & Perspective

"There is nothing worse than a sharp image of a fuzzy concept."—*Ansel Adams*

Back in the olden days, I had to carry numerous fixed-focal-length lenses for my medium-format Hasselblads. Zoom lens technology was still evolving, and those multi-focal-length lenses were primarily for 35mm cameras, not medium format. Because I was limited to fixed focal lengths, I learned the perspective characteristics of each—how telephotos compressed perspective and ultra-wide-angle lenses expanded it in dramatic ways if used correctly.

Today, zoom lenses, not fixed focal lengths, are the norm. The same principles and characteristics of lens perspective apply, though we are sometimes less aware of them when we zoom smoothly from one focal length to another.

What is perspective? The dictionary gives two definitions: (1) the art of drawing solid objects on a two-dimensional surface so as to give the right impression of their height, width, depth, and position in relation to each other when viewed from a particular point; and (2) a particular attitude toward or way of regarding something; a point of view. You might think only the first applies here, but the second—point of view—is also important.

The emphasis is on the final impact of the picture (e.g., perspective compression with telephoto, great depth of field and expanded perspective with wide angle). The expanded perspective of an ultra-wide-angle lens can be important for such things as forest photography. With the camera positioned at the base of a tree and pointed upward, you can capture the feeling of height and girth and magnificence of old-growth trees.

Point of view is important as well. Too often, we take photographs from eye level while standing. Changing your viewpoint will give a different perspective and often create more impact.

below. **This very tall and stately dipterocarp tree in the Borneo rainforest may be hundreds of years old. Photo made with an ultra-wide lens (15mm on a full-frame camera).**

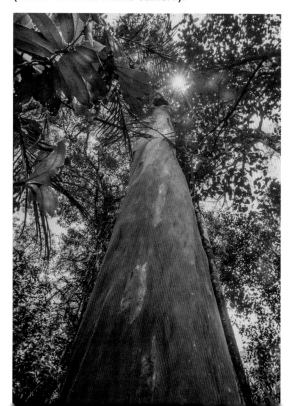

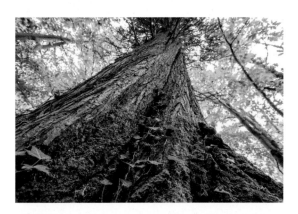

top. My daughter lives in the southern part of England and is fighting a battle to save a small national park near her home. A road is proposed that would slice through a part of this park, destroying some very old trees, such as this one. This photo looking up the trunk toward the forest canopy conveys a sense of the age of the tree and how it hosts other flora—mosses and other plants—at its base. This and other pictures of the forest are being used to rally public support to save the place. Lens: 10mm on a camera with an APS-C sensor (equivalent to 15mm on a full-frame camera). Photo Credit: Jean Norton.

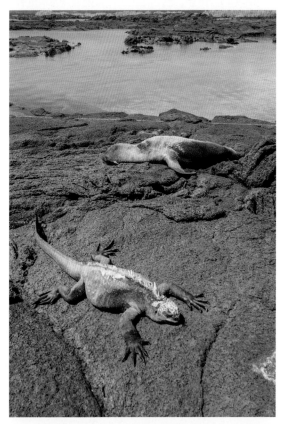

center. Photographed at eye level, this photo of a marine iguana and sea lion sleeping on the rocks in Galapagos Islands National Park isn't very dramatic.

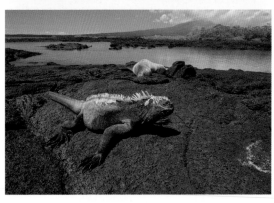

bottom. The same scene taken at a low angle gave a more intimate view of the life here. Incidentally, I checked with my guide to be sure I wasn't breaking any rules (we were following a trail that led across the lava formation) and held the camera at arm's length so that I wasn't too close to the iguana. I didn't want to make it move away. It didn't; it went back to sleep.

By varying both distance and focal length, dramatic perspectives can be captured. An ultra-wide-angle lens used close to a primary subject will give an expanded perspective, showing not only the primary subject, but a great deal of the background (though that background often is diminished and the primary subject dominates the photo). A longer focal length lens compresses that perspective and while showing the primary subject, the background will also be magnified and made more dramatic. Your choice will depend on the elements you wish to emphasize in the photograph.

Controlling Depth of Field

The optical versatility of zoom lenses gives us great opportunities to vary our approach to capturing subjects with visual impact. There are some optical pitfalls, though. It

top left. Think perspective when preparing to photograph a scene or subject. This young hiker in Alaska was photographed with an ultra-wide-angle lens, equivalent to a 20mm lens on a full-frame DSLR or DSLM. The mountains are diminished in size and seem far away.

bottom left. Same subject shot from farther back with a medium telephoto, a 200mm lens on a full-frame camera. The subject is the same size in the frame, but the mountains are more dramatic.

top right. This juniper tree is growing on a ledge in Canyonlands National Park in Utah. I photographed it with a 100mm lens and an aperture of f/11. The depth of field is not large enough to make the background sharp, but it is sufficient to make it somewhat distracting.

bottom right. For this photo, I chose a larger aperture (f/4) to make the depth of field more shallow. The tree now stands out against the background, which is less distracting.

has to do with depth of field. Many times, we need to eliminate certain distracting elements in pictures. At the same time, it is necessary to choose an f/stop that gives enough depth of field to maintain overall sharpness of a primary subject.

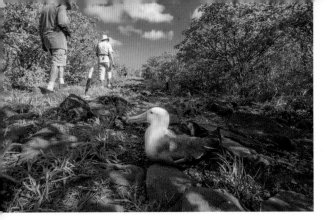

Depth of field is dependent on three things:

1. Distance of lens to subject.
2. Focal length of the lens.
3. The lens aperture or f/stop.

The one thing to keep in mind is that depth of field does not begin or end abruptly but, rather, takes place as a gradual transition of sharpness (or unsharpness). Controlling depth of field becomes important when you wish to isolate your subject from its background or relate a subject to its background by keeping both sharp. So the three things mentioned above are key to both aspects.

Here are two examples of isolating a primary subject from the background. In both cases the lens focal length was 100mm—a medium telephoto. In the first an aperture of f/11 was used and you can see that the background, while not sharp, is very apparent and distracting. The second photo was made with an f/stop of f/4 and the juniper tree now stands out quite nicely from its background in an almost 3D effect. In both cases I wanted to maintain a sense of place, in the canyon country of Utah.

For many conservation issues, your point of view and choice of focal length can be important in telling your story. In the Galapagos Islands National Park there has been growing concern about human impact as the number of visitors increase. As a result, strict rules have been put in place, requiring all visitor to have trained guides and that all visitors are to stay on designated and marked trails. In telling part of this story, I photographed this wave albatross (also called Galapagos albatross) that chose to build its nest close to one of those trails. It was undisturbed by the presence of people walking by and, from my observations over the years of coming here, the guides do a good job of keeping people on those trails. In many instances of documenting this interaction of people and wildlife here, I chose a very low angle of view to better show this interaction. In addition, I used a 16mm ultra-wide-angle focal length on the zoom lens of my DSLR.

I often look for different ways of capturing familiar subjects. Take time to examine the scene or subject and see if there is an angle of view that is different enough to attract attention.

Things to consider when choosing lens focal length:

- What perspective do you want: wide or compressed?
- How do the picture elements in the photo relate or interact?
- Choose a high point of view? Or low? What's the impact?
- A variety of perspectives gives you choice later for best impact.

It's All About the Subject Matter

"Landscape photography is the supreme test of the photographer—
and often the supreme disappointment."—*Ansel Adams*

Why are you a nature photographer? What is there about nature that makes you passionate about photographing it? Birds? Trees and forests? Flowers and plants? Insects? Reptiles and amphibians? Animals in the wild? Rivers? Mountains? Swamps? Deserts? Seashores? Your answer, very likely, is *all of the above.*

My reason for asking is to get you thinking about your whole relationship with nature. Chances are, if you live in an urban environment, you find your visits to wild country refreshing, invigorating, and inspiring. You visit nature with the idea of capturing, in photographs, what it is that brings out in you good feelings about wildness—the uplifting of spirit, solitude, inspiration, and beauty.

What does this have to do with conservation? *Everything.* Your subject matter becomes that which really matters to you. You want to make it matter to others because you want to rally support for your cause.

As a nature photographer, you can capture the delicate beauty of a butterfly on a flower. You may also photograph that butterfly on the flower with a bulldozer in the background. This points to the fact that you need to become a *documentary photographer* as well as a nature photographer. This will entail photographing certain subjects and scenes that had never appealed to you

before. Storytelling is what documentary photography is all about, and your story will have many facets to it. Resign yourself to the fact that often you will have to photograph the good, the bad, and the ugly. Think *story.*

Here's a common scenario: a threat arises in or near an important piece of unspoiled nature. It could range from a small area only a few score acres in size or a large area spanning hundreds, even hundreds of thousands, of acres. Logging, mining, dam building, road construction, commercial developments—are all threats to the sanctity and wildness and biodiversity of places. So, what can you do?

Think *value*—not monetary value, but spiritual and educational value, as well as value to society, now and in the future. For many people, this threatened place may be cherished for its beauty and solitude alone. Capture that aspect by photographing a lone child sitting quietly beneath a tree and reading a book or watching the wind rippling through leaves above, a family camping beside a sparkling stream, or early-morning shafts of sunlight piercing stately trees and illuminating soft foliage below, conveying peacefulness.

Then there's the biological diversity this place represents. It has value. Biodiversity is being lost in so many places worldwide.

What wildlife species are part of this ecosystem? Not just the megafauna; the smaller critters are important, too.

Monetary value can sometimes be used as an argument for preservation. In many places, tourism is a major economic benefit of having a wilderness area or a national park nearby. So your documentation, as I mentioned above, can show people enjoying nature.

Not all of your documentation may be dedicated to giving protection to unprotected places. Often, there are detrimental things happening in our protected lands, and it's vital to record and bring to public attention these threats. In addition, photos of certain activities and damages can be of legal importance in alleviating them.

Human impact in our national parks and other reserves has damaged some delicate ecosystems. For example, in the high desert of Utah, in Canyonlands and Arches National Park and other places, there is something called *cryptogamic* or *cryptobiotic* soils in the form of crusts. These soils are comprised of microscopic organisms that perform important ecological roles, including carbon and nitrogen fixation, retention of water for nutrients, and soil stabilization. Footprints, cattle grazing, and especially off-road vehicles can cause serious damage that may take a century or more to recover. Think *story.*

As a conservation photographer, you must ask yourself, "How do I portray my concerns?" If you are involved in a project that hopes to protect a certain place, it's

obvious you must capture the essence of that place—the beauty, solitude, grandeur, and details. The documentation should have a variety of images—bird and animal life, forest, flowers and plants, water in all its forms that nourishes the life here. You should also show people enjoying it— hiking, picnicking, photographing it. It is particularly effective to show young people enjoying nature; they are part of the story.

Research

Research is vital before embarking on a major documentation project. In the past, this research took lots of time, but today, using the Internet and email, you can gather a lot of information about a region and its ecosystems in a relatively short time. Be thorough in your research and be sure to contact researchers in the region who can give advice and important information. Check with regional government agencies and universities that may have biological and ecological studies going on. All of this information can guide you in selecting what to photograph, and it makes your photos more important and relevant.

When working in the field, often I find it necessary to sit and absorb quietly my surroundings. If I am with companions, I like to wander off by myself, because simply interacting with friends is a distraction. I need to concentrate. I may put the cameras aside for a while and just look, listen, and breathe in the aromas. It is a Zen-like state in which I try to open my senses to everything happening around me. There is an importance to simply taking it all in. In time, something will catch my attention— the play of light on leaves, sparkles of ripples in a stream, the way a flower sways in a breeze, or the deep, straight shadows cast by stately trees. When I have begun to feel and recognize the interconnectedness of the elements in a given place, I pick up the camera and try to relate it in one or more images. I don't always succeed on the first try. In fact, sometimes I don't succeed at all. Often, though, I find myself looking for entirely different ways of portraying the familiar. I'm bored with the old ways I have made images. I want someone to look at this photo and say, "Yes, that's the way I feel about it, too." Ansel Adams was once quoted as saying, "I can look at a fine photograph and sometimes I can hear music." Shoot for the rhapsody, listen for the symphony.

I don't know what it is, but sometimes images just leap out at you, like those visual puzzles "How many squirrels (horses, lions, …) can you find in this picture?" you see in magazines or newspapers occasionally. You stare and stare, and all of a sudden what was once a jumble of shapes and lines pops out as something recognizable.

Forest Photography

It happened in the dense forest of the Bikin River Valley in the Siberian Far East. I was there to document the forest in this valley because it was threatened by massive logging. It was especially important because this is habitat for some of the last remaining Siberian tigers (estimates vary, but some put it at only 300 left in the wild). This is not typical Siberian taiga (boreal forest), with the ramrod-straight pines, larches, and stark-white birches found over much of Siberia. This region is Asian temperate forest, reminiscent of a jungle. It looks like rain forest, with lianas wrapped

around giant birches in a stranglehold; dense, feathery ferns standing hip-deep in spongy soil; brambles that reach out and snare sleeves, collars, and camera straps and leave itchy little scratches on bare skin.

I was hiking through this forest, following what was supposed to be a trail, cursing at the dense foliage for hooking onto the tripod slung over my shoulder, glancing back over that same shoulder frequently (this is Siberian tiger domain; there aren't many left, but I'd seen a huge tiger track the day before), sweating in the humidity and heat, swatting those pesky little flies that hover a few inches in front of your eyes, when I saw it. Except for close-up details, I had almost given up on broader forest shots because of the density of foliage. (Yeah, yeah, I know . . . can't see the forest for the trees.) There it was: a graceful old Manchurian oak tree embraced lovingly by another, younger tree. I felt like a voyeur. How many centuries has this hanky panky been going on?

It was an obvious tripod shot, and because of the density of the vegetation, I didn't have a lot of room. I finally composed the picture using my 35–70mm zoom set at 35mm. I would like to have

left. I used a 35–70mm lens at about 35mm for this image. The undergrowth was so thick in this forest that it was difficult to isolate some elements to convey a sense of the lushness and biodiversity here. I felt it was important because this whole valley, the Bikin River, in the Russian far east was destined to be clear-cut logged by a major foreign corporation. I did manage to find this old Manchurian oak tree embraced by a younger one.

right. Moving inside that Bikin forest to photograph presented difficulties because of the chaos of vegetation. I did find one view of a fallen and decaying tree trunk with a wild ginseng plant in the foreground (lower right). The plant gave a center of interest to stand out against the jumble of other vegetation. Overall, this image gives a strong sense of the biodiversity of this ecosystem. I used a 20mm ultra-wide-angle lens to include enough background in the view and create a sense of depth.

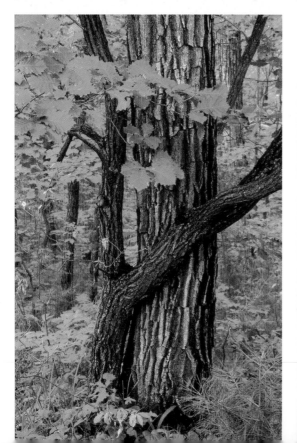

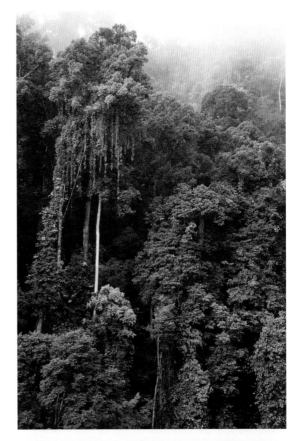

backed off and used a telephoto, maybe a 200mm, to isolate the subjects and drop out some of the background with shallow depth of field, but I couldn't because of all the branches in the way. As it turned out, the shot with the 35mm lens captured well what I saw and felt. In a short distance, I began to find other good photo possibilities as the forest opened up a little and the forest floor was covered with ferns and grasses.

My group met with indigenous Udege people living in this valley and later worked with them to help stop the proposed logging. These people got the valley protected as an indigenous national park, later to also become part of a World Heritage Site. There are still Siberian tigers here!

For forest photography, wide and ultra-wide-angle focal lengths,10mm to 35mm, can be useful. Why? Forest ecosystems tend to be confining and chaotic, especially in rain forests. Sometimes, as noted above, it's desirable to back off to get an overall view, but in the confines of a dense forest, that's not always possible. Even though you may be on a well-maintained trail, it's hard to back up and get a shot looking at or into the forest, so the wider angle of view becomes necessary to get that interface shot. I also like to have a lower perspective to show parts of the forest floor. It helps to visually convey the biodiversity of such locations.

A technique for portraying an overall sense of the forest is to find a *natural* opening or forest edge and photograph that edge straight on. I emphasize *natural* because, for example, if you use the open forest edge along a road or highway, it probably will include certain unnatural vegetation

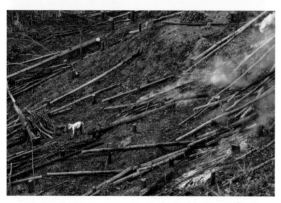

top. **The "bathtub ring" effect in a reservoir behind a dam. This is the inevitable drop in water level that comes about in order to feed electrical generating turbines or to divert water for irrigation of crops.**

center. **A free-flowing river has a riparian zone of plants that thrive along the shores and provide both habitat and food for numerous species. Shot at almost ground and water level with a 20mm ultra-wide focal length to emphasize the grasses along the shore and the clarity of the water. Slow seasonal fluctuations of the river level allow time for the plants and animal life to adapt.**

bottom. **Rain forests of Borneo are being destroyed by this form of agriculture—slash and burn.**

that sprang up in association with the disturbance in building the road. A natural edge containing normal vegetation would be along a river, stream, pond, or natural meadow in the forest interior.

Sunlight is a killer of photographs in a forest because of the immense contrast range. Dappled lighting results in white hot spots of light and black holes for shadows. With film, it was impossible to blend all that into a single picture, because films just weren't capable of handling those extremes in a single exposure. The sensors in digital cameras today are better in that regard, but still, it's difficult. Some people use HDR; they make several exposures with the camera on a tripod, then blend them in Photoshop to capture both the hot spots and the dim shadows. However, a great many HDR photos do not look real. Many overcorrect for the great range of brightness and darkness and create something almost surreal. I prefer to wait for better lighting conditions.

Fortunately, in many of the rain forests I visit, it is often overcast and rainy (they don't call it *rain forest* for nothing). That softer overcast lighting is perfect because it reduces the extreme contrast and brings out the colors in vegetation, especially after a rainfall. However, there is still the vegetative density to deal with. In some areas of the Amazon basin, where I've documented the rain forest, I found some places where I can get above the ground and even at the top level of the forest canopy. These have been at eco-lodges that have constructed platforms or towers to provide visitors views from above ground—perfect for giving a different perspective of rain forests.

Not surprisingly, it does rain in rain forests. When it stops, the vegetation gleams. Things get a little soggy and dry out later. (Camera gear is stored in waterproof bags and covers.) The photographs of wet forest work well. I look for images that would evoke that smell, feeling of wetness, and boundless diversity of life springing from it. I look for what's different about a place.

So, you've done a good job of capturing the essence of a place. Now you should also consider what will happen if that place is not protected. What are the threats? Logging? Land development? Mining? A dam? Seek out other places that have fallen victim to such things and show the consequences. We can discover, or re-discover, ugliness through photographs, and certainly side-by-side comparisons of the spoiled and unspoiled have huge impact.

If you've trained yourself to seek out and capture the beauty of nature, you may find it difficult, at first, to document the destruction and devastation of it. That's the dichotomy. However, we can use some of the same principles of composition, lighting, and perspective to convey the starkness of destruction. It is not our task to create beauty out of ugliness but, rather, to emphasize the ugliness created by destruction.

Here's a case in point: we know that dams create havoc to the life of free-flowing rivers, and often the lakes formed behind the dams become sterile waters in comparison. Part of this effect comes from drawdown, the inevitable drop in water level that comes about in order to feed electrical-generating turbines or to divert water for irrigation of crops. The filling and dropping of the water level creates a sterile life zone because aquatic plants and animals cannot maintain themselves in this changing zone. The same thing is true of terrestrial species that might take hold temporarily, but then are drowned as the water rises again. Some have referred to this dead zone as the "bathtub ring" effect.

Pairing that photograph with another of a free-flowing river and its variety in a riparian life zone can be effective in convincing people that a dam is very damaging. You may say, "But rivers fluctuate, running high and fast with spring runoff, and have less water as summer progresses to autumn." In a healthy riparian zone along free-flowing rivers, vegetation has adapted to seasonal flow changes, not

below. **Such rain forest destruction threatens the last remaining orangutans of Borneo, listed as critically endangered.**

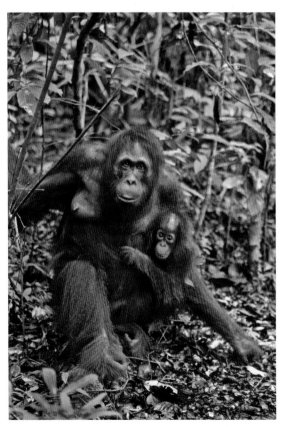

abrupt ones in reservoirs behind dams. This is an important distinction.

Worldwide, forests are being cut for various commercial purposes. Loss of forests has a large impact on global warming because trees sequester carbon through photosynthesis and reduce the greenhouse contributor carbon dioxide on a large scale. In addition, massive logging destroys vital habitat for numerous species. In Borneo, one of the major species on the brink of extinction is the orangutan. In my presentations and in books and magazines, I pair certain Borneo photos to drive home the point of critical habitat loss.

As a documentary photographer, you should look for indirect messages about what is happening to the environment in a given region. On one of my trips to the Amazon basin of Peru, I photographed boxes of chainsaws off-loaded from the plane I was a passenger on to Puerto Maldonado. In an indirect way, the photo shows what's happening to some of the rain forest in the region.

top. Another major threat to the Borneo rain forest is palm oil plantations. This lucrative crop produces an oil used in a variety of foodstuffs worldwide. Here, the biodiverse forest is replaced by a monocultural crop. Because of this, orangutans and other species are on the verge of extinction.

bottom. That's a lot of chainsaws! These were off-loaded from the plane that took me to the heart of the rain forest in the Amazon basin part of Peru. This gives you an idea of what is going on in terms of rain forest destruction here.

top. Though this photo was made in 1982 on the coast of Maine, it illustrates how signs like this can alert us to threats not readily visible. I hope it has been cleaned up for I love New England clam chowder.

bottom. On an assignment for *Audubon* magazine, I documented the war on elephant and rhino poachers in East Africa. This badge was worn by a ranger in Tsavo National Park.

Signs also can be indicative of something wrong in the environment. Sometimes it's not possible to photograph pollution because it may be in an invisible but still toxic form.

Lake Baikal in Siberia is one of the most beautiful spots in the world and a source of Russian pride. In my early travels there, I worked with a team of Russian and American ecologists in the early 1990s to have Baikal declared a World Heritage Site (it was so declared in 1996). I made a photo *(page 46)* on Yarki Island at the northern tip of the lake, and the irony of it is that I shot it behind the cabins used for summer field studies by ecology students at the University of Irkutsk.

I live in Colorado, and I don't have to travel far to see and photograph the destructive effects of mining on the land. In many cases, it's not just the mining operation itself, but the aftermath. Many of these mines were started in the mad gold and silver rush days of the 19th century and carried over into the 20th century. Most were abandoned when the gold or silver ran out. The majority of these were underground mines, so the surface damage was far less than open-pit mines. However, the tailings left behind have become major sources of pollution from exposed minerals leaching out. Some of these toxic elements in the tailings include arsenic, mercury, cadmium, and certain radioactive minerals.

In the early 1970s, when I participated in Project Documerica, the task over the next few years was to document the state of the environment in America—the good, the bad, and the ugly. We had our choices of what to photograph. At first, I chose to portray some of the beauty of the Rocky

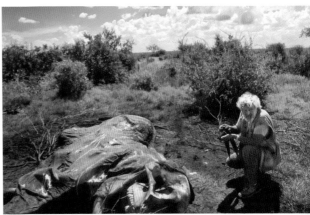

top. **Some assignments come close to combat photography. I documented anti-poaching rangers on patrol in Tsavo National Park in Kenya. During this time, some park rangers had been killed by poachers armed with AK-47s and other potent weaponry.**

bottom. **It was no fun to have to photograph an elephant killed by poachers just days before I arrived in Tsavo National Park in Kenya.**

Mountain West. However, as time went by, and as I traveled throughout the region, I became aware that places here were experiencing more and more destructive impacts from mining, logging, dam building, and industrialization. It became important for me to document the bad and the ugly.

I learned of some ranchers in northern Montana who were fighting to keep their lands from being strip-mined for coal. Due to a quirk in state laws, they did not own the rights to the minerals under their ranches. They were under siege by mining

companies to strip mine their land for those coal deposits beneath the fertile grasslands. I spent considerable time with a couple of ranchers documenting both their way of life and the ugly scars of open-pit mines inching their way toward their ranches.

top left. Part of the story. These tusks were confiscated from captured or killed poachers. The amount of ivory in this guarded storage room in Kenya represented 40 to 50 elephants that had been killed—a fraction of the thousands slaughtered across the continent.

bottom left. The good, the bad, and certainly this is the ugly. Sometimes it's necessary to shock people by showing the horrors of poaching: a rhino with horns cut off, killed by poachers.

top right. The good: my friend, the late Anna Merz, and Samia, her black rhino raised after being orphaned as a calf by poachers. Anna funded and ran a rhino sanctuary at Lewa Conservancy in central Kenya. Rhinos, both black and white varieties, are protected and bred to maintain the species and to return to other protected reserves and parks.

bottom right. Irony can be powerful, but with some photos it only becomes clear with accompanying captions. This was made on Yarki Island at the northern tip of Lake Baikal in Siberia, a place of great beauty, revered by most Russians. I shot the photo behind the cabins used for summer field studies by *ecology students* at the University of Irkutsk. I think they missed an important subject in their classes.

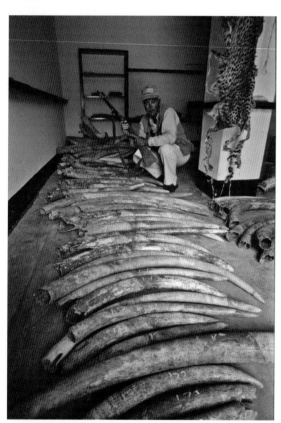

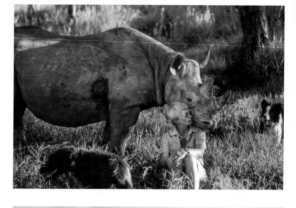

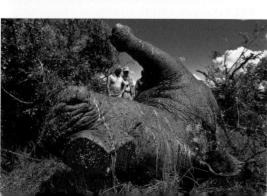

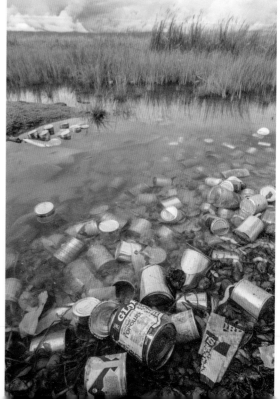

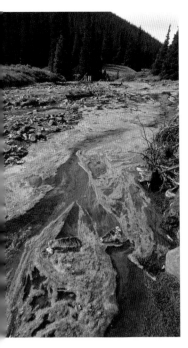

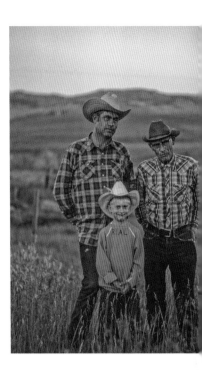

left. A Colorado mountain stream polluted by runoff from mine tailings left behind when the mine was abandoned decades ago. Farther down the mountain this stream and other streams tainted by mine tailings runoff (there were a great many mines in this region) empty into the Animas River, which is hyped as a great trout fishing stream. I think I'll pass on a trout dinner from this river. Mercury, cadmium, arsenic, anyone?

center. The mine tailings that are polluting the stream in the previous photo.

right. In their battle to save their land from strip mining I felt it important to photograph John *(left)* and Bud the elder *(right),* and young Rial Redding *(center)* to add the human element to the conservation story. I chose a time of day, near dusk, when the lighting was soft and flattering and gave a lovely soft glow to the ranchlands in the background. I used a 100mm focal length and a large aperture to render the background slightly out of focus and subdued, almost painterly in appearance.

The human element becomes part of your documentation. People are a part of the equation in environmental threats. The Redding family had three generations living on this ranch: Bud the dad, John the grown son, and Rial the youngster who would presumably inherit this ranch if left untouched. This documentation took place more than four decades ago. I have tried to find out what has happened to the ranch. I appeal to you to visit the region (contact me for information about the locale) and continue this documentation. Is the ranch still there, or did the mining company win?

My Documerica photographs are free to use from the National Archives website (now on flickr: https://www.flickr.com/search/?q=boyd%20norton). With updated images of the area, it is an important story to be told.

Currently, a controversy rages over fracking in various parts of the country. Is it safe? What are the dangers (groundwater contamination, for one)? How do you portray the downside of fracking? These are the challenges, among others, facing a conservation photographer. First of all, fracking takes place underground,

and those impacts cannot be seen. However, there are some things that are visible in certain places. Methane released from fracking has leaked into underground water supplies, and tap water in nearby homes is actually flammable. Video and still photos have shown flames coming out of faucets. Part of the story.

There is another aspect of the human element in your documentation of

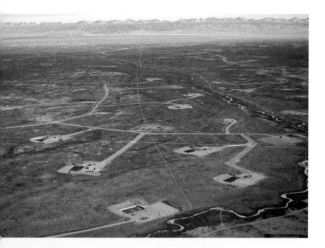

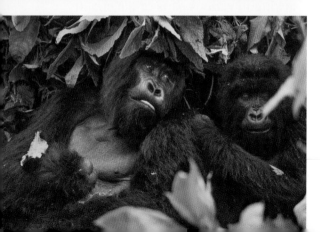

environmental issues: *poverty.* Around the world, people are living on the edge of survival for lack of food and shelter. To survive, they often turn to poaching and encroaching protected forest reserves for fuel and food. In Africa, the poaching of endangered elephants and rhinos is often carried out by organized, well-armed gangs for enormous profits rather than for food. In other parts of Africa, poaching for meat is prevalent. Just outside, and sometimes inside, the Serengeti ecosystem, it is estimated that upward of 100,000 wildebeests are killed for food each year. For many decades, poachers set snares in the forests of the Virunga region of Rwanda and Democratic Republic of the Congo for small animals, and often the mountain gorillas were caught and died from infections of the wounds.

I was impressed with a photograph I saw by Scott Trageser while I was judging a photo contest sponsored by the North American Nature Photography Association. His photo won First Place; it shows two people of the indigenous Mro Tribe of Bangladesh holding a pair of Oriental pied hornbills. These birds will earn them $70 on a local market for the pet trade, and that

top. **The extent of oil and gas development and fracking is sometimes not apparent at ground level. In the west, it is widespread, as seen in this aerial photo. Photo credit: Wendy Shattil.**

center. **Snares were set in Rwanda's rain forest by poachers to capture small mammals for food. However, the mountain gorillas here in Volcanoes National Park sometimes tangled with the snares; the resulting wounds became infected, causing death.**

bottom. **This silverback lost his right hand when, as youngster, that hand was caught in a snare. He was lucky to have survived. Photos like these help to illustrate some of the problems affecting wildlife and ecosystems everywhere.**

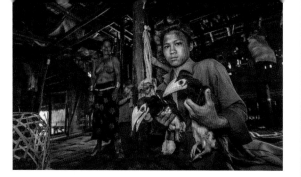

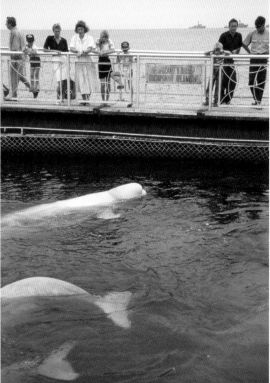

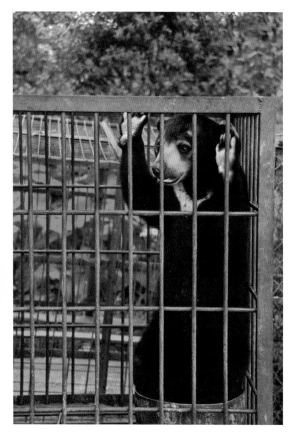

above. In the words of photographer Scott Trageser: "Members of the indigenous Mro tribes still seek a harmonious life within the forests of Bangladesh. Unfortunately, the forest resources are dwindling, as are the fertility of their croplands. These Oriental pied hornbills will fetch $70 in a local market, which is used to buy rice, which can no longer be grown. Our organization, the Creative Conservation Alliance, is creating solutions for the betterment of the forest and the people, Chittagong Hill Tracts. It is our vision to provide the indigenous people with alternatives to wildlife trade and slash-and-burn agriculture before they are left with no choice but to burn down what is left of their fatherland." Photo credit: Scott Trageser.

bottom left. This young sun bear is destined for the pet or zoo trade. I photographed this in the state of Sarawak in Malaysian Borneo. It is listed as "vulnerable" on the IUCN Red List, but may soon be listed as endangered.

top and bottom right. While some zoos and aquariums have improved living conditions for confined animals and birds, this was not the case for this so-called dolphinarium that I photographed in Vladivostok, Russia. These wide-ranging beluga whales were confined to pitifully small tanks.

money will buy them rice because their own rice plantings failed due to drought.

In recent times, many zoos and aquariums have improved their living conditions for animals and birds, providing settings close to natural habitat. However, there are some unregulated game farms, usually catering to photographers, that keep such

top left. While the bark beetle is natural to conifer forests and has a role in their ecosystem, warmer winters due to climate change have helped it spread and flourish. Current research shows that warming summer and winter temperatures are driving beetle population outbreaks in susceptible forests, allowing these insects to persist in habitats previously constrained by cold temperatures. Shown here, silvery dead and dying spruce and fir forests in northern Wyoming impacted by the bark beetles. This region no longer experiences consistent sub-zero winters that killed beetles and controlled beetle populations.

bottom left. Sitka spruce forests in coastal Alaska on the Kenai Peninsula no longer experience consistent sub-zero temperatures that control beetle populations. The reddish brown needles indicate massive die-offs of these trees.

top right. A healthy coral reef is vibrant with life. Corals are marine invertebrates living in compact colonies of many individual polyps. They secrete calcium to form hard skeletons. They are both food source and protective habitat for many marine species.

bottom right. When stressed by such things as temperature change or pollution, coral polyps will die, causing coral bleaching that can kill the colony if the stress is not mitigated. Shown here, "bleached" elkhorn coral—a colony dead from likely warming of Caribbean waters in the U.S. Virgin Islands.

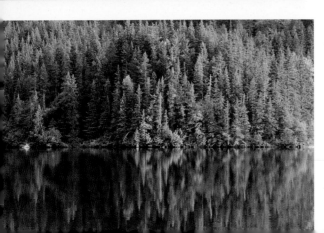

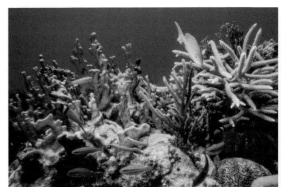

species as wolves, mountain lions, and even tigers, in small, confined enclosures. If you care about wild species, you may want to think twice about paying large fees to photograph animals kept in appalling conditions. (On page 92, you'll read about South African conservation photographer Ian Michler's work to stop "canned hunting" of lions and other species.)

Global Warming/Climate Change

No, it is not necessary for you to travel to the Arctic or Antarctic to document the effects of global warming and climate change. Look around you. There may be signs already of such effects taking place near your own home. Where I live in the Rocky Mountain West, some of our forests are being drastically affected by warming. This is due to a small boring insect called pine bark beetle or another called spruce budworm. In the past, when winter temperature often fell below 0 degrees for days at a time, many of these insects were killed in the trees' interior. But now long periods of milder winter weather allow these insects to flourish, and many trees—whole forests, in fact—are dying. The same is true in farther north climates, as in Alaska. (See photos on the previous page.)

top. Unregulated development, as in the U.S. Virgin Islands several years ago, caused silt-laden runoff after rains. This runoff caused die-offs of some coral reefs covered by that silt.

bottom. These petrogylphs along the Snake River would have been flooded under hundreds of feet of water if a dam had been built in the lower end of Hells Canyon on the Idaho–Oregon border. Saving such prehistoric records was another good argument for protecting this gorge.

top. These are a combination of pictograph and petroglyph—carving in rock with vegetable and ochre coloring rubbed on the figures. They are located in a canyon adjacent to Canyonlands National Park in Utah, a place that should have been included in the park for protection.

bottom. This Anasazi ruin, likely used to store grain or corn raised on the canyon floor, is in a large, archeologically important canyon adjacent to Utah's Canyonlands National Park. It should have been added to the park to aid in preventing vandalism and theft of important artifacts.

Historical & Prehistorical Values

In your quest to document biodiversity and aesthetic values of a place, don't overlook possible historical or even prehistorical values. This will often require some extensive research on your part, but you can find help from college and university researchers in your region. Should there be some archeology findings in a place, it adds one more argument for preservation—and researchers who are investigating the history or prehistory may be good allies in arguing for protection.

Photo Illustrations/ Image Manipulation

My advice here is: be very, very careful in using manipulated images! The ethical thing to do is to state that the image is a photo illustration or a manipulated or constructed image, to make a point about a threat or danger. That should be put in a caption or accompanying text and in the metadata. Incidentally, in chapter 1, I show a photo of a coal-fired power plant spewing dark smoke. That photo was made decades ago and shot with Kodachrome film. That slide was scanned to digitize it, but after digitizing, it would have been easy to manipulate it. I did not try to make that smoke darker and more ominous. I have one of the original Kodachrome slides in my files as proof that there was no manipulation.

There are many other situations where it may be tempting to add or take away elements in a picture. Having been one of the judges in numerous nature photography contests, it's always a problem to decide how much manipulation has taken place in photos, beyond normal adjustments for color correction, contrast, spot removal, cropping and exposure. The North American Nature Photography Association (NANPA) has very strict guidelines for

entries in its numerous photo contests, and these include rules warning against image manipulation beyond those adjustments just mentioned.

Captions

It is very important to have good caption information with your pictures. This can and should be done in the metadata during the time you process your digital images. As I've mentioned before, some photographs will require a good caption in order for a viewer to gain understanding of an issue or threat. The exception is when you are giving presentations and you can verbally explain what the photo portrays.

What Do I Photograph?

- Think *story.*
- Do your research carefully.
- Document the good, the bad, and the ugly.
- Document beautiful places and the details of elements within.
- Document the destruction wrought by mining, logging, dams, climate change, and other developments.
- Photograph signs that indicate dangers.
- Determine if there are archeological values here and document them.
- Ultra-wide angle lenses can relate the ugly in the foreground to something beautiful in the background, and vice versa.
- Include the human element—people affected by destructive developments.
- Document people enjoying wild nature in parks and reserves.
- Avoid supporting "canned" photography of species kept in very confined conditions.
- If you manipulate an image to make something look worse than it is, you should label it as a *photo illustration* or *manipulated image.*

right. **This is a manipulated image. I used it in some presentations to illustrate that there was a federal order issued to allow oil drilling and fracking on private and public lands adjacent to our national parks and other protected lands. To my knowledge, that order is still in effect, though it has not been implemented here in Jackson Hole and Grand Teton National Park.**

Protecting the Prairie & the Sagebrush Country

Photo credit: Michael Forsberg.

In Dave Showalter's own words:

"In the beginning, I wanted to tell a story about the Colorado prairie that folks often consider drive-through country. I just wanted to prove that there was a lot more out there than people gave the prairie credit for. Over time, I've gotten more deeply involved in western conservation and decided to focus almost completely on conservation photography in the American West because of habitat loss and fragmentation.

"There are large swaths of important habitat disappearing under pressure to drill and develop. That's taken me on a journey into the sagebrush ecosystem, working in the Platte River Watershed, collaborating with Michael Forsberg and the Platte Basin Timelapse project, and now the Colorado River Watershed. Just seeing iconic creatures like the greater sage-grouse so threatened because of shortsighted development and habitat loss compelled me to seek out partners and tell a conservation story.

"I've been advocating for the sagebrush ecosystem for more than a decade. I didn't start out to do a story about the greater sage-grouse. I was just simply looking at this western landscape and seeing enormous areas turned into industrial oil and gas fields. I soon realized that at the center of all this is our iconic western bird, the greater sage-grouse. They've been declining at roughly 2 percent per year for decades, and recent declines are particularly alarming. I just felt that I had to tell that story of the sagebrush ecosystem, which supports 350 species (including humans) around a single 'umbrella' species. In some ways, conservation projects choose us."

What do you think about using ugly photographs? Do those photos have value?
"Absolutely. How can we have a conversation about development impacts or road kill without images? What shocks us anymore? I think we have to show those kinds of photos and trust that some viewers will want to learn more. More importantly, we have to find a way to get people to study these photos, read the captions, and want

to look deeper. So, maybe there are artful ways of depicting death and destruction and getting folks to spend more time studying the image and wanting to understand the issue. We have to make people stop what they are doing, and that's really hard in this hyper-visual world."

What are the problems and issues you encounter in your work?

"A lot of my work is on our public lands in the American West and often on private lands in collaboration with a rancher/landowner. I'll frequently seek information and access opportunities with government agencies—a U.S. Forest Service or Bureau of Land Management office, for instance—finding the right person to contact to open the door, so to speak. My experience is that most people want to be helpful, and I think if your intentions are pure and you're coming from a conservation perspective, people recognize that. You just keep showing up. Persistence and professionalism are invaluable. There's nothing that replaces authenticity."

Do you work with researchers?

"For those of us working as conservation photographers, everything we do is grounded in science. So, working with researchers goes hand in hand with telling the story. You develop photo opportunities you wouldn't normally have, and those photos can contribute to a scientific record. It's an opportunity for everyone when we reach out to researchers and choose to make pictures that elevate their work and give our viewers a window into good science. I often work with researchers these days, and it's generally my first choice when going into the field. I rarely work alone. It's expensive to travel and go out for a few weeks, and if you can maximize your opportunities by working with researchers, it can really change the arc of your story."

below. Greater sage-grouse displaying on a lek (mating ground) in the sagebrush ecosystem of the American West. Greater sage-grouse are threatened but have no protection under the Endangered Species Act. Showalter has been rallying public attention to the plight of this species, hoping to achieve protection as an endangered species. Photo credit: Dave Showalter.

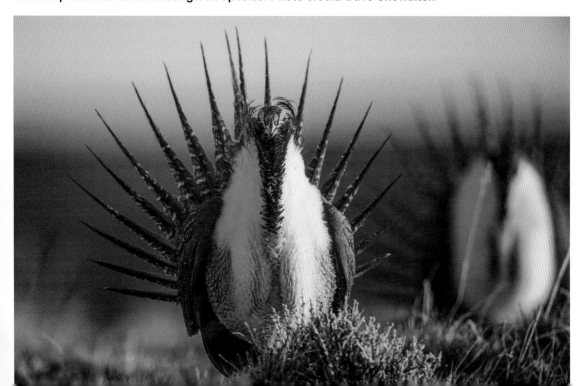

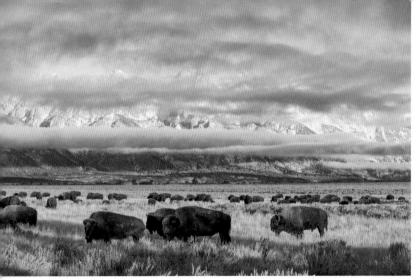

left. Dave Showalter's work centers around sagebrush country and prairie, home to remaining herds of bison. These are residents of Grand Teton National Park in Wyoming. Photo Credit: Dave Showalter.

"[The work of conservation photographer Joe Riis] . . . it's legendary work. Late in my *Sage Spirit* book project, I was contacted by University of Wyoming researchers for an assignment studying sagebrush songbirds in Wyoming's industrial gas fields. I learned about the Science Posse—biologists at the University of Wyoming studying Wyoming's wildlife and natural history. I've since accompanied a number of UW researchers in the field, working with a number of the same people that Joe [Riis] has."

Do you use specialized equipment?

"I use one camera trap—it's almost always in service. It is low-percentage work, but it's a perspective and tool that I think is really important for telling stories and photographing reclusive creatures without being there. I intend to grow that part of my photography, so I'll have more camera traps in the field soon."

Do you use drones?

"Yeah, I use a drone. I shoot video and stills for stories; the aerial perspective is important. You can't always schedule a flight with Lighthawk [an organization that works with leading conservation groups, offering flights to achieve significant conservation outcomes]. I'm able to fly with Lighthawk as a conservation partner occasionally to make aerial images, but sometimes you just need a higher perspective. That's when the drone is invaluable. Of course, there are restrictions with that. I don't fly a drone in closed areas or in wilderness areas when nobody's looking. I find it really disturbing when somebody's flying in a place where they shouldn't be. I certainly don't fly over wildlife. Our job is to go about our business the right way, to not cut corners, and to make sure the subject is more important than the photograph. If we keep those things in mind, that purity of purpose will eventually yield better stories and a better community. I think that's what we're trying to build here—a better community that cares about the natural world."

Do you use video?

"I use video in a variety of ways, from my own short movies to supporting the Platte Basin Timelapse project, and I've shot a bunch of videos and time-lapse for that. I use videos in my slide presentations to experience what a sage-grouse looks and sounds like in their habitat. Whatever the

story needs determines how to go about it—whether to shoot video, or stills, or both. It's all about storytelling and taking viewers on a journey so hopefully they'll care. In slide presentations, you see people sit up straighter when they view a really good video clip. It doesn't have to be very long. It gives an intimate window into that world and puts people in our place."

What is ethical behavior for photographers?

"This goes to the welfare of the subject. If I'm photographing a bird, I don't want to bump it off its perch, and I don't want to be the one who made that bird change its behavior. My job is just to be invisible when photographing wildlife and to let them live their wild lives unobstructed and unaltered. I take great measures to not disrupt behavior. The same thing goes for making landscape images. I don't need to be the person who tramples something fragile to make an image. So, I'm not going to walk across cryptogrammic soil crusts in the desert or fragile alpine tundra. I'll just let that image go.

"Regarding ethics, I ask that other photographer please, *please* always keep the welfare of the subject first and foremost before making an image."

What's next?

"I was once told that if you pick a project, pick it carefully because it'll be with you forever. I'm grateful for the projects I've picked. It's unfortunate that we have to continue fighting the same battles over and over when we have consensus here in the West that we ought to protect prairie and sage and our watersheds. So for me, personally, I'm still very engaged in grassland issues. It's still a top priority to continue battling for the sagebrush ecosystem and being a voice for sage-grouse that are plummeting rapidly now across the west. It can be discouraging at times when leaders in Washington make really bad decisions, but I'm super encouraged by folks that I work with—conservation groups, researchers, ILCP conservation photographers, agency people. They just put their heads down and keep working. I think that's our job: to just keep moving forward, beating the drum. My newest project with Braided River (publisher) covers the Colorado River watershed—a book project called *The Living Colorado.* The Colorado is an international river that connects most of the West, and though over-allocated, supports incredible wildlife and beauty and 40 million people. I think it's probably the most important work I could be doing, considering climate change is reducing the amount of snowpack, and therefore reducing the amount of water flow we have. So, I intend to be a voice for the living Colorado through my work and partnerships in the communities where I work. That's what's ahead for me."

Should other photographers get involved?

"Absolutely. We're all photographing beautiful places, portraying beauty, and we care about these places. If we care about the places we photograph, we have an obligation to share what's at stake with that love of beauty, of wild animals, and our place in these ecosystems. We all have something to say."

Picture Dynamics: Create Strong Images

"There are no rules for good photographs, there are only good photographs."

—*Ansel Adams*

I envy painters. As artists, they start with a blank canvas and add only those elements that combine to create a dynamic image, one that can grab your attention. True, not all paintings *do* grab your attention, and some are just downright boring. Nevertheless, the freedom of expression is there for the artist.

Photographers, on the other hand, are more limited and must work with the real world, one that contains much visual chaos. Though we can eliminate much of that visual chaos, we still have to work at making photos that are dynamic and exciting.

You may be thinking: as a conservation photographer, I may be photographing things that are ugly—destruction of ecosystems, dead or dying wildlife. Why worry about composing a good photograph?

The answer to that is *impact.* You are not trying to create beauty out of something ugly. Rather, you should try to draw atten-

tion to that destruction by portraying it in the strongest way possible.

Composition is the art of arranging visual elements to create the strongest images. My three important tips for creating dynamic compositions are: explore, isolate, and organize.

Explore

Explore the aspects of the scene or subject before firing away with the camera. Is the lighting right? Is there too much contrast? Would softer lighting be better for this subject? Or maybe harsh lighting, to create a feeling of something bad happening? What about the angle of view? Should you choose a high angle or a low angle? What perspective works? Should you choose a telephoto lens to compress the distance between the subject and background, or use a wide-angle lens and great depth of field to expand the perspective? Is the scene

left. **Clutter and visual chaos. No strong center of interest here. Isolate to remove that visual chaos.**
right. **There is good potential in the stream way back there.**
following page. **A much stronger composition, still conveying a sense of this quiet forest and stream.**

or subject relevant to the story without a long-winded explanation? Are any people who appear in the frame relevant to what is happening in the scene?

It's true that sometimes we have to work quickly and there isn't time for leisurely exploration—the light is changing rapidly or the wildlife is moving away. When time permits, though, give some thought as to how best to capture that scene or subject. As you gain experience you can often work quickly for the best rendition under changing conditions.

Isolate

Get rid of extraneous elements that clutter the composition. Move closer (unless the subject is a grizzly bear or lion). Isolate optically by zooming in.

Tighten things up. The most important part of this process is defining the subject or center of interest, which may be in the midst of a lot of clutter. At times, doing so may be difficult.

Our eyes are constantly moving, looking at various parts of a scene in front of us. Even while looking straight ahead, we are aware of objects in the periphery. But while we may have great peripheral vision, we also have a psychological cone of concentration. We mentally zero in on something in a scene that catches our fancy—a leaf, perhaps, in the midst of many others, or a small stream in the clutter of a forest.

Organize

This is what we normally think of as composition. What is the center of interest? Where do you place it in the scene? Should a horizon line be centered, high, or low in the picture? What is the impact of such placement?

The term *composition* refers to the arrangement of elements in a picture, but I prefer the term *picture dynamics* because it is a *dynamic* process. We need to think of how we arrange the various elements in a picture and how those elements interact. As

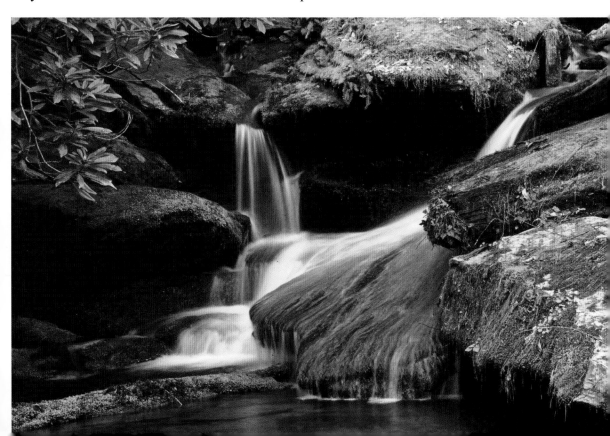

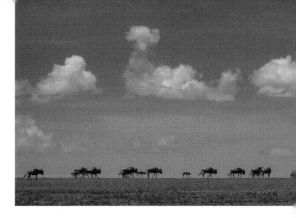

top and bottom left. **Vertical lines have a sense of strength and stability. A vertical format better emphasizes tallness and height, but both presentations have some sense of grandeur and perhaps stability.**

above. **Horizontal lines convey stability, earthiness. The low horizon in the photo gives the sense of openness and spaciousness you would expect in the Serengeti Plains.**

I said earlier, the painter has almost unlimited freedom to add or subtract visual elements in a picture. For photographers, the process is tougher; we have to deal with the chaos in front of the lens, decide how to eliminate the more distracting elements, and zero in on the important ones.

Let's consider the various visual elements that comprise any work of art, be it a drawing, painting, or photograph. These elements are lines, shapes, forms, textures, patterns, colors, and perspective or depth. The last one, perspective, is covered in chapter 5, where I discuss the attributes of various lens focal lengths.

Lines

Straight, curved, and implied lines (a series of objects aligned in certain ways have the properties of real lines) are everywhere in our world. In our images, vertical lines tend to create a sense of height, stability, and perhaps grandeur.

Horizontal lines convey stability, tranquility, and earthiness. Photographs with

horizontal lines often embody these attributes.

Horizontal and vertical lines connote something static and stable. Diagonal lines, on the other hand, are dynamic and unstable. If you want to convey a sense of action or movement in an image, be sure to emphasize diagonal lines in your photo.

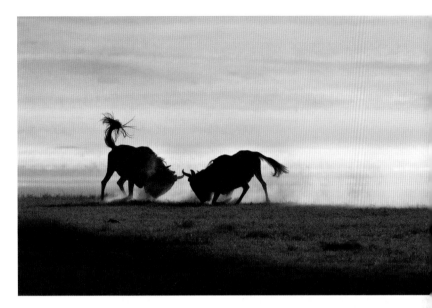

top. **These fighting wildebeests illustrate action with the diagonal slant of their backs, legs, and tails.**

center. **Diagonal lines are dynamic and denote action. You can almost feel the howling wind that has tilted these trees into a permanent lean in the Falkland Islands.**

bottom left and right. **In the left photo, the raft is almost centered in the frame and is flat on the water, both diminishing the feeling of action. In the right photo, the raft is off-center and has a diagonal slant, conveying a strong sense of movement and action.**

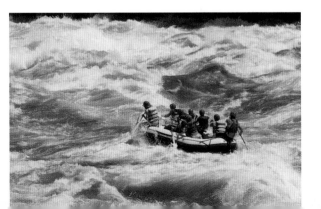

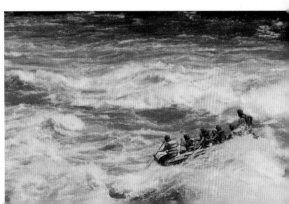

Shapes & Forms

From childhood on, we acquire a memory bank of recognizable shapes—circles, squares, triangles, and irregular shapes such as airplanes or birds in flight, trees, and more. Even when seeing them in silhouette, we instantly know what they are.

A painting or a photograph is a two-dimensional rendition of a scene or subject, made up of various interacting shapes. To give a sense of three dimensions, we must give form to those shapes. Light and shading is the way we do that. Sometimes it is subtle.

Texture

This represents the tactile quality of surfaces. Texture can vary from smooth to rough, and oblique lighting is important to bring out these qualities. Texture can also add dimension to a picture. Note how low-angle side lighting of the dried mud in this photo *(following page, top)* gives a sense of three dimensions and a feeling of the texture.

top and bottom left. **Receding or converging lines create a sense of depth in a photo. The greater sense of depth is depicted in the vertical shot and diminished in the horizontal version.**

top and bottom right. **In the top photo, the flat lighting does not give a sense of the forms of these sand dunes in Death Valley. For the bottom image, I added contrast and warmer lighting in Lightroom to bring out the forms of the dunes and the ripples in the sand.**

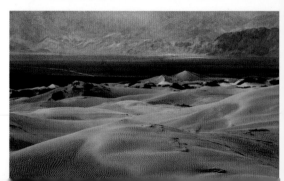

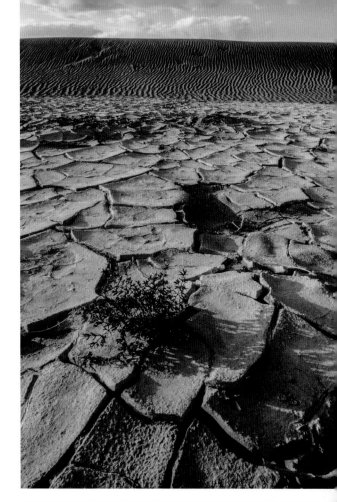

top. Low-angle side lighting brings out the texture of dried mud.

center and bottom. Blue is associated with coolness or coldness, as in this iceberg floating off the Antarctic Peninsula. In the center photo, I color corrected to make the iceberg appear a neutral white. In the bottom image, I adjusted to have a slight blue tone to give a feeling of the frigidness of the region.

Color

The human eye is capable of seeing a range of electromagnetic waves we call *light.* At the shorter wavelength of light is violet, and at the longer wavelength is red.

Aside from the purely physical aspects of light, certain colors in the visible spectrum have some psychological attributes that are important in creating strong photographs. Various colors evoke certain feelings or emotions. We can look at a photograph of a campfire and almost feel its warmth in the dancing red, orange, and yellow flames. At the other extreme, the subtle blue of a winter scene conveys coldness. Knowing these reactions can aid us in strengthening our photographs.

Back in the olden days of shooting film, certain color films were biased in how they recorded scenes and subjects under different lighting conditions. Kodachrome, for example, often required a warming filter in overcast light or open shade in order to compensate for a blue cast. Today's digital cameras make adjustments for white balance and help to eliminate much color bias. If it should occur, post-processing software can also correct such color bias.

Color is one of the strongest elements in picture dynamics because we react to color in very emotional ways. Our vocabulary reflects ways that certain colors affect us: "seeing red" as an indication of anger or

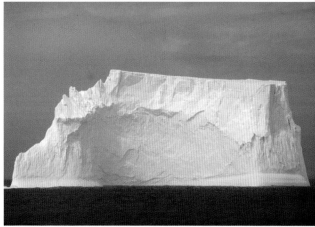

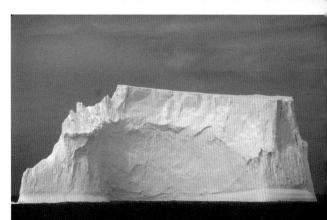

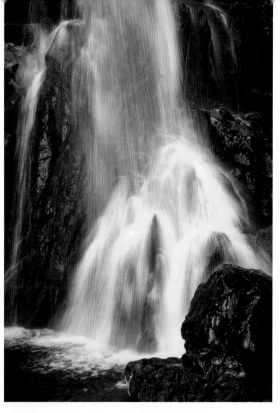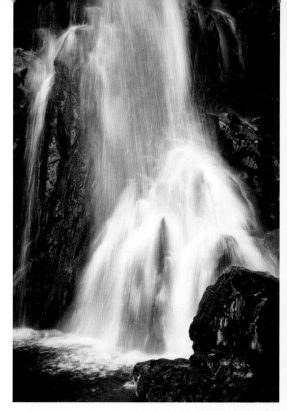

top left and right. The left photo of a waterfall in the Mt. Zirkel Wilderness Area in Colorado has a blue tinge that conveys the crisp coldness of Rocky Mountain streams fed by snowfields. The right photo was adjusted for more neutral color balance and does not have that feeling of coldness.

bottom left and right. You may convey a certain feeling or mood by altering the color tone. The left image has a feeling of a cold winter morning; the right photo has a warm summer evening feel.

sometimes danger, having "the blues" to denote sadness. The impact of color can be very subtle, or it can have strong impact on the success of a particular picture. Let's look at the spectrum of color and see what psychological implications there may be in photographic compositions.

Blue is the color of distant objects, and is thus considered a receding color. To me, blue seems a quiet color. Blue whispers. Blue is tranquil. It may also convey something quietly ominous.

Green is also a cool color, but less so than blue. Of course, we associate green

with nature, and it lends an air of quietness to a scene when it predominates—as in this English forest *(below)*. The blue flowers impart a small amount of coolness as well.

As we move up the spectrum toward the warmer end, yellow is a lively color imparting warmth. There's nothing subtle about yellow. Both yellow and orange

top left. Blue is often referred to in art terms as a *receding color* because distant subjects often have a tinge of blue haze.

top right. Blue may be a quiet, tranquil color, but it may also signal something subtly ominous, as in this photo looking into the core of a nuclear reactor at Los Alamos Laboratory in New Mexico.

bottom left. The greenery of an English forest conveys a subtle sense of coolness.

bottom right. In addition to conveying a certain amount of coolness, green, to me, is also a quiet color, as in the silent realm of this forest in the Russian Far East. This place is home to the remaining Siberian tigers in the wild, estimated at only about 300. Two books, *The Tiger* by John Valliant and *Tigers in the Snow* by my friend Peter Matthiessen detailed the killing rampage of two Siberian tigers in this place. If these books had been published before I visited this forest, I would have looked over my shoulder more often.

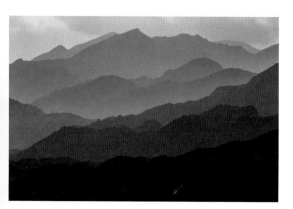

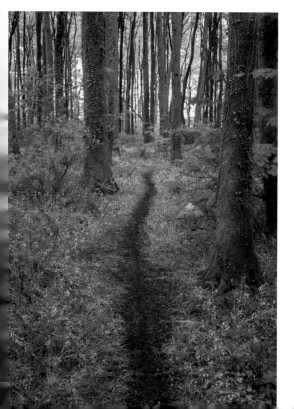

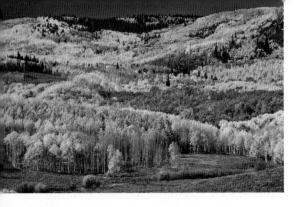

top. **Yellow and orange are colors that shout for attention in photographs. They also make us think of hillsides ablaze with those colors in autumn. If I were trying to depict the damage of a logging operation in the foreground, I would not choose to do it in the autumn. Those bright, fiery colors would attract attention and diminish the impact of what I wished to convey.**

bottom and right. **Red shouts even louder than yellow or orange. These Sally lightfoot crabs on the black lava in the Galapagos Islands are brilliant red and stand out. Red is also a sign of danger. This sign was on the fence surrounding a leaching pond in Colorado. The cyanide leaches gold out of tailing piles from old mines. Even though the pond was lined with heavy neoprene rubber, local citizens are rightly concerned about this poison leaking into ground water.**

make us think of autumn—foliage turning, pumpkins at a farmer's market.

Patterns

I include this as one of the elements of design or composition because patterns are useful in making us see things in a different way. The key to capturing a good pattern is in conveying some unity or rhythm.

Horizontal versus Vertical

Orientation does make a difference in terms of a photograph's impact. Think of it this way: a horizontal shot is like looking out a picture window. You can see the sweep of a landscape from side to side, and this helps convey a sense of openness and grandeur on a large scale. A vertical photograph, on the other hand, is like gazing out a narrow window. You look into a landscape from foreground to background. This may make it important to have strong elements in the foreground because you are looking directly into them.

In addition, horizontal and vertical orientations have a different sense of scale.

For example, if you wish to convey the height or depth of a canyon, the vertical shot can emphasize that.

Horizontal photos give more space to allow the eye to sweep side to side. Vertical photos restrict that side-to-side viewing and force the viewer to look into the picture from foreground to background. In addition, a vertical orientation emphasizes the height of scenes or objects.

top left. Pattern photos can be useful to draw attention to a particular object or subject. The rhythmic flow of lines draws attention to the center, where the lines converge. Illustrated here is a pattern created by a fern in a Russian forest and looking straight down at it. There is a rhythmic flow of lines and shapes and colors, all leading the eye to that leaf in the bottom center.

bottom left. Here is a pattern that may not be so pleasing, the rhythmic march of towers and power lines across the desert, made by a fellow Documerica photographer, Chuck O'Rear, in the 1970s. All Documerica photos are in public domain.

top and bottom right. In the horizontal photo, the steepness of the Owyhee River gorge in southeastern Oregon is diminished. Note how much more dramatic the canyon seems by shooting it as a vertical to emphasize the steepness.

How does knowledge of all these compositional elements help you to portray issues around saving places? Often, the contrast between the spoiled and the unspoiled helps reinforce the need to protect wild lands. Here's an example from my work on Project Documerica. In chapter 5, I showed the photo of two Montana ranchers fighting to save their land from strip mining of coal. I visited the coal company's office and asked permission to photograph what they said was land that was reclaimed—that is, after the mining had taken place, the huge open pits were filled in with overburden

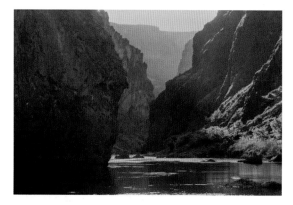

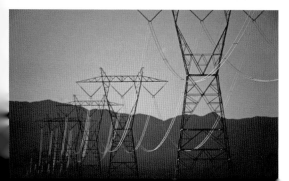

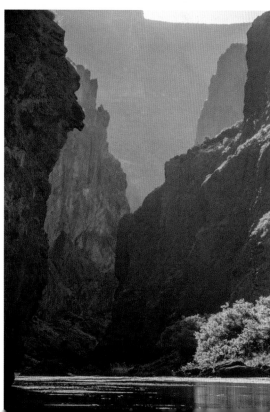

that had been removed to get at the coal. Grass was planted on this reclamation plot and watered, almost constantly. The company's public relation person proudly showed me this "reclaimed" area, pointing out that it might take a few years for the land to return to normal. (I learned later that this "reclaimed" plot of land had been mined 20 years earlier, and it still looked pretty ugly; see the photo on the left.) After seeing this, the obvious question comes to mind: Will this place ever return to productive ranch or farm lands?

Feelings ran high in this region. Due to a quirk in Montana law, those ranchers did not own the mineral rights beneath their lands. Some ranches had been in families for generations.

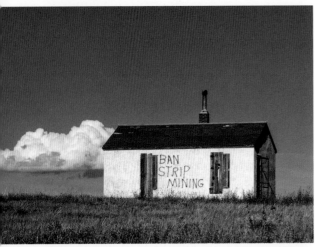

Make an Impact

• Compose your photos carefully to tell your story in the most powerful way.
• Look for the human element and document what is affecting people and their way of life.
• Even the ugliest scene should be composed in such a way as to make the viewer feel that something should be done to stop what's going on.
• Comparisons have impact. Show the good alongside the bad to add emphasis to saving a place.

top. **This is an attempt to reclaim land that was strip mined in Montana. I chose an ultra-wide angle lens (a 20mm on full frame camera) close to the ground to show the pitiful blades of grass (non-native grass, I learned). I also timed my visit to use direct midday light for harshness to depict and emphasize the sparseness of the growth.**

center. **Part of the story: documenting the fight of Montana ranchers trying to save their lands from strip mining. Graffiti on a shed on a ranch.**

bottom. **One rancher's son had a toy car emblazoned with a bumper sticker expressing the feelings here.**

The Drama of Details

"It's not what you look at that matters, it's what you see."—*Henry David Thoreau*

What do close-up photographs do for us? Close-ups have power, mainly because the minutiae of our world often goes unnoticed. For example, the tiny elements—flowers, insects, lichens, and other things in an ecosystem—are a part of the story, showing the interconnectedness of all things. We all appreciate a wonderful landscape photograph of an inspiring place, but taking the time to focus on equally lovely small things helps give others an appreciation for the incredible diversity in nature. These can become a key part of your story. For many viewers, it's a wakeup call to the importance of protecting all parts of an ecosystem.

It's easy to overlook some of the elements of a story—and keep in mind that some details don't require a macro lens, just an eye for small details. Case in point: on one of my trips to Borneo, I was photographing an orangutan sanctuary where young ones, orphaned by logging of their habitat, were being taught how to survive in the wild. The mothers, who pass on knowledge of what to eat in the forest, had been killed by the loggers, so the youngsters needed to be educated over a long period of time on how to survive on their own. The program was successful; numerous orangutans were returned to the wild in protected rain forest reserves. However,

I noticed one adult that was caged, and I learned that he had been rescued as a victim of the pet trade. He had grown up in the company of humans and had no survival skills for the wild. He was doomed to spend the rest of his adult life in the slammer. I took a close-up photo *(following page)* to portray, symbolically, what might happen to all orangutans if their rain forest habitat continues to be destroyed.

Snakes are not the favorite critter of most people, so it's a challenge to convey the importance and beauty—yes, I said *beauty*—of snakes. Some are not only beautifully patterned, but that pattern sometimes makes them masters of camouflage. On assignment for *Audubon* magazine to do a story on snakes with declining populations, I photographed timber rattlesnakes at their hibernating dens in upstate New York. (I had to promise the researchers that I would not divulge the location of these dens. Apparently, collectors found it lucrative to capture and sell these snakes to zoos and other collectors, thus depleting the population.)

What use are close-up photographs in conservation? They can convey strongly the biodiversity in nature and can make people aware of beauty on a small scale. Moreover, it is very often the small critters that become endangered first, and by

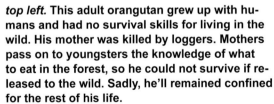

top left. **This adult orangutan grew up with humans and had no survival skills for living in the wild. His mother was killed by loggers. Mothers pass on to youngsters the knowledge of what to eat in the forest, so he could not survive if released to the wild. Sadly, he'll remained confined for the rest of his life.**

bottom left. **People terrify snakes. I found this timber rattlesnake sunning itself next to its rocky den. It did not rattle nor did it move or even flick out its tongue. It felt secure amid the leaves hiding most of its body. After photographing it, I moved on quietly to photograph other timber rattlers at this denning site. When I returned to where this first one had been, it was gone. It quietly slipped away.**

top right. **As part of that *Audubon* assignment, I also visited a "rattlesnake roundup" in Oklahoma. This western diamondback rattlesnake was on exhibit. It may appear risky to handle it in this way, being free to bite the handler, but there was no risk. *This snake's mouth had been sewn shut,* leaving enough space for its tongue to flick out—the most disgusting display of animal cruelty.**

showing good photographs of these small creatures, it may be possible to keep them from disappearing. In my presentations, I point out how all these things in the food chain are interconnected and why it is necessary to protect as many as we can.

In my decades of travels in Africa, I have spent much time in places like Serengeti National Park crawling on hands and knees photographing such things as dung beetles. Why would I bother with such a lowly creature? It turns out that dung beetles are a vital part of the Serengeti ecosystem. Rolling that golf-ball sized piece of dung, the beetle eventually finds a spot to bury it and lays its eggs within the buried ball. Now, it may not seem like much, but there are millions of dung beetles in the Serengeti ecosystem burying dung almost continually, day and night. That seemingly simple act multiplied by the millions has created an amazingly efficient means of fertilizing those grasslands. In turn, the lush grasslands feed the herbivores, which in turn feed the predators, and the whole web of life in that ecosystem carries on.

However, as use of insecticides increases in many parts of Africa, some of them could be carried on the wind into protected areas like the Serengeti. If dung beetles should begin to die off, their role as fertilizer spreaders diminishes, and it could result

top. **Dung beetles have a great impact on the Serengeti ecosystem.**

center. **These lush grasslands would not be the same if it weren't for the dung beetles and their fertilizing chore.**

bottom. **That's just a fraction of the wildebeest and zebras that feed on those grasslands fertilized by the lowly dung beetles.**

in diminishing the quality of the grasslands. It doesn't take much imagination to see that this could then have a chain-reaction effect: fewer grasses mean fewer herbivores, which means fewer predators, and on down the food chain. Part of the story.

The tundra of the far northern parts of our continent and in our mountain regions above timberline is another fascinating ecosystem. While it may seem, from a distance, to be a sterile and, at times, almost lifeless environment, the diminutive plants and critters that thrive there are important—and fascinating. By definition, *tundra* is a biome where trees and certain other plants are limited by low temperatures and short growing seasons. Special adaptations are required to survive. The vegetation is made up of dwarf plants—shrubs, sedges and grasses, mosses and lichens.

Stretching across northern Alaska, from west to east, is the Brooks Range, containing some of the wildest regions of North America. On the north slope of the Brooks Range are the coastal plains that extend to the Arctic Ocean. This is tundra on a vast scale. It's also a region that has been exploited for oil and continues to be threatened by more such developments. One such area threatened is the Arctic National Wildlife Refuge (ANWR).

While parts of this land seem featureless compared to the spectacular mountains of

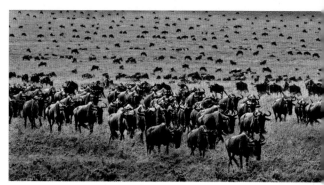

Alaska, there is much to photograph here. You need to get on your hands and knees and sometimes on your belly. There, you will discover an infinite variety of photo subjects.

While some zoom lenses have so-called macro focusing capabilities, in reality you may find that most don't give you good close-ups of really small subjects. For these, you'll need a separate macro lens. Common focal lengths are 50, 55, or 60mm, and others around 100mm. The shorter will allow, when stopped down to f/22, more depth of field to bring more parts of the subject into focus. However, you will be working closer to the subject with this focal length and may scare off insects you are trying to photograph. I usually use a 100mm macro lens, which allows me to give space to certain animate subjects and not frighten them off. There are also a few longer macro lenses of 180 or 200mm that will give even more space, though they are also physically larger to carry around. Incidentally, keep in mind that if you choose, say, a 100mm macro lens and use it on a camera body with a APS-C size sensor, it will, with the crop factor, be like using a 150mm macro lens on a full-frame camera.

Most macro lenses, regardless of focal length, will allow focusing down to a 1:1 magnification ratio; that is, the subject will be recorded on film or sensor as life size. You can add an extension tube between the camera body and lens for even greater magnification.

top. **Some people look upon the vast treeless tundra of the far north as a wasteland, but by focusing on some of the minute details, you can show some of the diminutive beauty found here. Photo made with a 55mm macro lens with camera on a tripod.**

bottom. **Not only is there diminutive beauty to be found across the tundra, but far from being a useless wasteland, some of these plants are primary food for large mammals such as caribou. Those white-ish plants are caribou lichens, an important food for the tens of thousands of these Arctic deer that migrate here. Part of the story.**

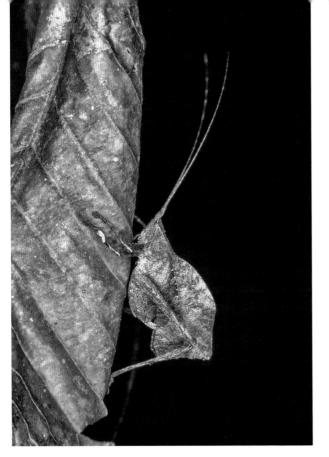

left. Macro photography conveys the wonder and diversity of nature and, in turn, helps make people realize the interconnectedness of things in our environment. This photo was made in the Peru rain forest with a ringlight flash on a 100mm macro lens. It conveys the wonder of how animals and insects have adapted to their environment. This leaf-mimicking insect evolved this way to protect against being eaten by birds. From a distance, you would be hard pressed to spot this insect against the riot of foliage in the forest.

right. In recent years, the bee population in North America, Europe, and other places has fallen dramatically. The consequences of this are enormous, as bees provide vital pollination of many domestic and wild plants. One calculation suggests that every third bite of food you eat was pollinated by a bee. Here is an opportunity to tell this story. It won't be easy, as elements of the story are difficult to photograph—insecticides being used, bees dying, effects on hives—but you can start with macro photos of bees on flowers, and go from there. This photo was made with a 100mm macro lens, a hand-held camera, and soft, overcast lighting.

When working in the field, I like to keep my equipment to a minimum, so only under certain circumstances do I use flash. Most often in daytime photography I use a higher ISO setting on the camera so that I have a sufficiently fast shutter speed for subjects that might be moving slightly or in dimmer lighting or if I can't use a tripod. However, some of my rain forest macro work was done at night, because that's when it was easiest to find certain critters of the forest. There, I used a ringlight flash for an even form of lighting. One great advantage of using flash is that the light is so bright that it allows smaller apertures for more depth of field. In addition, the brightness coupled with a reasonably fast shutter speed allows you to hand-hold the

above. **This moth was photographed at night on the colorful helliconia bloom in the Tambopa-ta-Candamo rain forest reserve in Peru. I used a ringlight on a 100mm macro lens to give an even illumination. The range of light from the flash was short enough to keep the background black and non-disturbing visually.**

top right. **A 100mm macro lens fitted with an LED ringlight that provides soft, even illumination. These LED lights have one advantage over using flash: the continuous lighting allows following a moving subject and also works well for video.**

movements of subjects in the dark for continuous shooting. They provide excellent lighting on small subjects and throw off almost no heat that might disturb delicate or sensitive subjects. If you are shooting video, they are vital for shooting at night. A drawback: if you are trying to cover a wide area of view or need illumination to cover something many feet from the camera, you will need one of the very large LED lights or several smaller ones. The larger LED lights are bulky and heavy—a disadvantage if you're trying to travel light.

camera and position yourself with freedom of movement.

There are other supplemental lighting units using LEDs, and they have some advantages over flash. The constant light from LEDs allows you to follow the

Master of Minutiea

I call Clay Bolt the World's Beekeeper. He has worked diligently to raise awareness of the importance of bees to all of us. At the same time, he has alerted us to the plummeting population of bees most everywhere. So many photographers these days tend to focus on the charismatic megafauna—the elephants, lions, tigers, and bears—but Clay has brought to our attention the little things that are so important in all ecosystems.

Clay Bolt in his own words:

"Throughout my life, I've had twin passions: the first, a passion for nature with a particular focus on insects. Some of my earliest memories were of raising praying mantises and loving beetles and dragonflies. I don't know where it came from, it was always just there. The other thing I always loved in my life was drawing and illustration and painting. I was always using my visual skills to talk about the natural world. I ended up going to college and getting a degree in graphic design. When I graduated in '98, I began working in advertising and soon found that it was not really what I had in mind for my career.

"I took a trip to Australia, and in western Australia, orchids were blooming and the bird life was amazing. It was like I was seeing nature for the first time. The photos that I made on that trip were terrible, but I became obsessed with the idea of making a good photo.

Back in South Carolina, I began photographing the things around where I lived, and I got better at photography. I then reached out to the local chapter of The Nature Conservancy (TNC). Looking through their files, I realized they had a lot of landscapes, but they didn't have photos of salamanders and all the other amazing things we had in that area. That was really the beginning for me—it was probably around 2002, 2003 maybe. From that point on, I began working with nonprofits to really fill in the gaps in their collections. At that time, not many people were using macro photography as a conservation tool. I felt lucky to get in at that point and started to build a name for myself.

"I get asked a lot these days, 'What does it matter to protect little things that no one has ever heard of, and don't you feel helpless doing what you're doing when in this time, everything is under threat of extinction?' Yeah, it's hard and it's challenging, but I don't have another option. It's not a viable solution for me to ignore it. I care so

top. The common Eastern bumble bee (Bombus impatiens) is a species that appears to be expanding its range, while some others are in decline. Madison, WI. Photo credit: Clay Bolt.

bottom. Highly endangered rusty-patched bumble bee (Bombus affinis), Madison, WI. Photo credit: Clay Bolt.

much about this beauty. You've gotta do it; you can't look away.

"It's really amazing to me how many nature photographers don't know much about nature. Imagine being a sports photographer and not understanding the rules of the game. If you are really passionate about photographing nature, it seems to me the most obvious thing you can do is to advocate for the protection of nature.

"Everyone wants to go to some exotic location. As an example, you're a budding conservation photographer, 17 years old, and want to make a difference, but you don't have the money to fly around the world. Start in your community. I think about pollinators, for example. One of the things I always encourage people to do during my talks is, start with your backyard, make it into a pollinator haven, and then go to your neighbor and say 'Can we do this in your yard?' then take some of the seeds from your garden and plant them in their garden so that they can have bees.

"If you care about nature, start where you live, because you can see the results of your work. You are part of your community, you can meet decision makers, and compel people to make a huge difference. If you have a desire to do bigger things in other places, those kinds of lesson you learn at home will have a big impact in other places.

"If you care about nature and are doing photography, I implore you to get involved in conservation because your subject matter, frankly, is going away."

What about ugly photos?

"I think we have a responsibility to document a story from all aspects. Don't go into it just for the shock value all the time, and don't go into it for the beauty all the time—find that balance. I think with any kind of image, beautiful or ugly, these types of things require thought. Shock factor alone is not going to do it; it's about how this ugly photo fits into the story. These types of things require thought, because it's more about how this ugly photo fits in with the bigger story. I always

think of these things (shocking images) as almost like punctuation. You want to hook people and punch them in the gut sometimes, because you want them to feel the pain of what happened. If it's all beauty all the time, it's not necessarily going to help, and vice-versa, so I really think it's like anything in life—it's all about balance."

What problems do you encounter in your work?

"People feel that they need a lot of money to start a project. For example, maybe you don't get a story in *National Geographic* to fund your work—that's so rare. But you can go to a small nonprofit and say 'Hey, I know you probably don't have a lot of money to pay me outright, but can we work on submitting a grant together?' Being clever about how you get the funding can permit you to have the money to allow you to do the work you want to do. I worked with TNC to get grant money to document an oyster reef restoration program, and it worked out well for both of us. If you champion a cause, you owe it to the subject to continue to follow it."

below. **A black-tailed bumble bee (Bombus melanopygus) flies in front of the Golden Gate Bridge. Photo credit: Clay Bolt.**

Can you continue to work on these projects year after year?

"I think when you get involved with something, you have to make a commitment that you're going to see it through. At this point, I've been working on bees for about six years, and a lot of people ask me, 'Are you still working on bees?' At some time, I may move on, but I continue to see stories that need to be told."

Let's talk about using new—and rapidly changing—technology.

"I am really excited about the in-camera focus stacking that certain camera manufacturers are building into their cameras. I never kill any insects that I'm trying to photograph or do anything to immobilize the subject. So, because of that, when I'm photographing things moving very rapidly, focus stacking is not really an option. When it comes to technology, the thing that excites me most is the higher ISO capabilities. I often use flash to capture things flying very quickly, but to have the scene look natural it would be best to use a high ISO and fast shutter speed rather than flash. I'm not a gadget person when it comes to photography. I'm not the person who is chasing the latest and greatest camera or lens, but being able to shoot in very low light comes down to the ISO. That really does excite me. Image stabilization is another great thing these days."

How do you use video?

"If somebody asked me what I do, I'd say I'm a photographer, but really what I would say is that I'm a communicator—a conservation communicator. I use photography, writing, and video—all of these different things—to help convey a message. Video has a way of speaking to people, just as photography can freeze a moment. For example, I knew that it would be very hard for people to fall in love with a rusty-patched bumble bee, being an insect in particular, you couldn't get a sense of the way it moves, the habitat it lives in. I wanted people to get a better sense of the bee. [My video] is the next best thing to seeing it move, hearing it, and seeing the beauty of it. I would say that this film was instrumental in getting it on the Endangered Species list. There were screenings all across the country. The video was great: when I couldn't speak or get on the stage to talk, the video could do the talking for me. Those tools together are part of the artist's palette to talk about conservation."

Do you use drones and remote cameras?

"I think with drones and remote cameras, the key again is understanding the biology of your subject. Animals in our world are aware of what's happening around them, and we need to be careful not to stress them.

"Camera traps that are documenting diurnal species during the daytime with very short bursts of flash are probably not going to have a tremendous impact on a subject, as opposed to photographing a nocturnal animal. You can imagine a strong flash in the eyes of that animal—that flash could temporarily blind a subject, and it could be preyed upon by a predator.

"Take the time to work with biologists to understand a species, and make sure you're doing the best you can. Always do the right thing—at the very least, use due diligence to make sure that the subject isn't harmed or stressed. How can you work in

conservation photography and not care about your subject?

What can you say about the ethics of conservation photography?

"Ethical behavior is putting your subject first. There are moments when I wanted to photograph something that I've never seen before—maybe it's something I've looked for, for a long time, and I found it, but I knew that if I took that shot, I would disrupt what was going on and disrupt the animal. Who knows what kind of ripple effect I would have in its life? It's just not worth it. I wouldn't feel good about showing anyone that image knowing in the back of my mind that I stressed the subject. For example, I love snakes. Like a lot of people, when I first started photographing snakes, I wasn't aware of the effects or wasn't concerned about one in a strike position. I don't do that anymore because I realize now that like so many photos I see of snakes, the animals are in a defensive position, and that's only mildly interesting. That's an animal that's afraid. I'd rather take the time to watch the snake and get a natural behavior. It is worth the effort. From a business standpoint, even the editors you want to work with know the difference between a threatened animal and an animal that is behaving naturally. It comes down to putting your subject's wellbeing first and being willing to call it quits if the animal is not so not doing well in your presence.

"I would encourage photographers who are just beginning to explore conservation photography to find something that needs a champion and be that champion. It's tempting to photograph elephants, bald eagles, and other things you need to photograph. That's fine until you try to sell your work and realize the market's flooded with these images, and there are plenty of photographers who are advocating for those species. Instead, advocate for some unknown humble things that need help and support. By doing that, you become the expert on that subject, which shows editors that you know how to tell a story and you've taken time to research the subject. You have a chance to make a difference there.

"I'm really glad I stuck to what I believed in and what I was passionate about, because that's allowed me to work and to make a difference over the last several years.

"You try to use your work to spur people into action. I want to make people fall in love with my subject. After they fall in love, I want to say, 'Well, if you love this, here's the situation.' So for me, it's all about building that story arch. Building awareness in itself is great, but it really doesn't do much to protect something. You've gotta be ready to say, 'Okay, you care about this. Right now, this is what I need you to do.' Think through what you want your audience to do."

Get Creative

"The real voyage of discovery consists not in seeking new lands but in seeing with new eyes."—Marcel Proust

Photos shot from the same perspective and using the same technique all the time are boring. Maybe it's time to think outside the box and get a little more creative.

While on assignment in East Africa to document the serious poaching problems, I was in Kenya's Tsavo National Park, where organized poaching gangs armed with AK-47s were very active. Some park rangers had been killed by the poachers. It was necessary to keep an eye out for the poachers hiding in the brush along the roads and to drive faster than normal past any good hiding places. I made a shot of driving on that lonely road. To convey a sense of speed, I used a slow shutter speed and a 20mm wide-angle lens.

While on that assignment, I began to wonder what the East African savannas will look like a hundred years or more from now with continued, unchecked global warming. These two photos *(below)* were my impressionistic rendering.

below. Tooling through the backcountry of Tsavo National Park in Kenya, hoping to avoid armed poachers hiding in the brush. We were traveling fast. To capture that feeling, I used a 20mm wide-angle lens and shot with a $1/15$ second shutter speed. This swishing effect blurred the edges but kept the center reasonably sharp.

top and bottom right. My impressionistic interpretation of the east African savannas a hundred years from now if global warming is not slowed or halted. These were shot with a 15mm ultrawide angle lens and a red filter.

left. I call this "wet-belly photography." This wild iris was growing amid grasses and other irises on the coastal tundra of Kamishak Bay, AK. I shot this using a 200mm focal length lens with extension tubes to allow close focusing. I used a wide aperture of f/4 and shot through grasses and another flower close to the front of the lens, giving a soft, out-of-focus color effect.

above. These reflections in a pool of water in fall are another way of presenting to people the beauty of nature in a visual way.

If you are hoping to save a place through your photography, sometimes it's helpful to step away from normal ways of documenting nature and beautiful lands.

The Serengeti ecosystem in East Africa is the focus of my recent conservation work. The major threat here has been a proposed high-speed commercial highway that would slice across Serengeti National Park. Biologists and other researchers fear that this road could have huge impact on the greatest land mammal migration on earth, perhaps even wiping it out and causing a precipitous decline in animal life all along the food chain. Each year, more than two million animals—wildebeests, zebras, and other herbivores—migrate from the Masai Mara in Kenya into the Serengeti in search of water and fresh grasses. Following the seasonal rains, the herds make a 300-mile annual circuit, returning eventually to the Masai Mara.

The big challenge photographically is to capture the magnitude of this migration. Aerial photography in the past has given a sense of the animal population, but at the same time, the noise of aircraft or helicopters spooks the herds and causes them to scatter. A drone? Maybe, but again, these are not without noise.

Being on the ground is perhaps the greatest challenge, for you have to find the right terrain at the right time to get the shots that give an idea of the animal density here. Straight-on shots at the same level don't quite do it. A place with a slight rise of land looking down and out in the distance seems to work best. Aerial photos from a plane, helicopter, or drone would also work, but again, the noise made by these would more than likely spook the animals and cause them to disperse.

The animals in this great migration are always on the move. The wildebeest are often running, and to capture this I often use a blur pan technique. This entails using

top. **Look up! Sometimes the sky has its own beauty. On an assignment for *Conde Nast Traveler*, I saw these lovely, graceful cirrus clouds over the mountains in Hamber Provincial Park in British Columbia. To me, this helps to convey the clean, unpolluted air of protected places.**

bottom. **A slightly elevated view from a small hill gave a good sense of the magnitude of the migrating animals in the Serengeti. Shooting from the same level as the animals makes it difficult to convey the mass of wildebeest, but using a noisy drone or plane would panic the animals.**

a long focal length—300mm or 400mm—and shooting at a relatively slow shutter speed of $1/15$ second or so while panning with the action. This creates a streaked and blurred background, and sometimes part of the animal remains relatively sharp, as you are moving the camera with the animal's direction of movement. Shoot lots, because this is a very imprecise technique.

If you are an experienced landscape photographer, you likely know that a polarizing filter helps to eliminate distant haze in shots. So-called haze filters, however, don't do much. Haze is caused by tiny particles of water, smoke, or dust in the air, and the effect is amplified by sunlight reflecting off those particles. Polarizers cut that glare and diminish the appearance of haze. However, as a conservation photographer, you may want to keep haze in the photo to make a point about diminishing air quality, so take off the polarizer.

Some of your conservation photography may best be done from the air. Aerial photos help give the big picture of what is happening in certain areas. Shooting on the ground can make it difficult to capture the magnitude of destruction taking place. During some of my work for Project Documerica, I used aerial photography—particularly to show the destruction to ranchlands by strip mining in Montana.

Win with Words

Our battle to save Hells Canyon from a major, destructive dam project was helped, in part, by the words of the power company seeking to build the dam. This company produced a fancy brochure with illustrations (but no photos) to convince the public that the dam would be of great recreational benefit. In addition, the description of the canyon was denigrating, attempting to downplay the spectacular nature of the

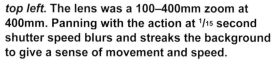

top left. The lens was a 100–400mm zoom at 400mm. Panning with the action at ¹/₁₅ second shutter speed blurs and streaks the background to give a sense of movement and speed.

bottom left. This elk herd was in a region of Montana where hunting was allowed each fall, so they were spooked by humans. When they began to run at my approach, I set my 100–400mm zoom to 400mm and panned with the action using a ¹/₁₅ second shutter speed to blur the background and give a sense of movement to the picture.

top right. Blur pan of orangutan mother swinging through the Borneo rain forest with youngster clinging to her. About ¹/₂₀ second shutter speed.

center right. It's never fun to photograph pollution, but often it's necessary to keep reminding us that we have to strive to do better. There is a city down there in this aerial photo—Mexico City. Millions of people are breathing that air.

bottom right. An aerial photo of strip mining in northern Montana, made on one of my assignments for Project Documerica. Combined with photos made on the ground of unspoiled prairie and productive ranchlands, photos like this can have impact. If you use a drone for photos such as this, check on local laws and restrictions.

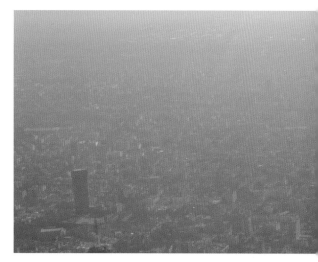

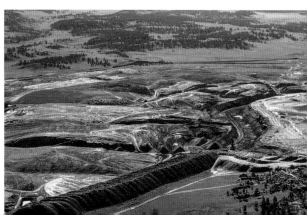

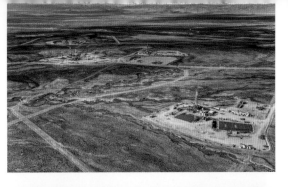

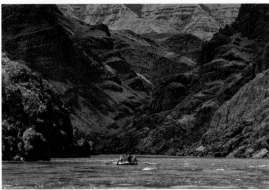

top left. Wendy Shattill is a well-known conservation photographer in the Rocky Mountain West. She and her partner Bob Rozinski have done a great job of documenting the detrimental effects of oil and gas drilling. This aerial photo shows the extent of such operations, in this case in the Red Desert region of southwest Wyoming. From a distance, this treeless region may look barren and devoid of life, but it is important habitat for many species—particularly, it is an important winter habitat for deer, elk, and the largest migratory herd of pronghorn antelope. Increasing road-building and drilling operations have a big impact on wildlife. Photo credit: Wendy Shattill.

top right. "It is, in no sense, a spectacular gash, like the Grand Canyon of the Colorado." These were the words of the power company planning to build the dam that would put this and other parts of Hells Canyon under hundreds of feet of water. Not spectacular? Really?

bottom left. Hells Canyon is, indeed, listed as the deepest gorge in North America. It is now protected as the Hells Canyon National Recreation Area and Wilderness.

bottom right. This was the proposed site of an open pit mine in the heart of the White Cloud Mountains in Idaho, a pristine wilderness deserving national park status.

gorge. When *Audubon* published my article and photographs, we included some quotes from the power company's brochure:

> *There is the misconception that grows from generalized descriptions of Hells Canyon—the "deepest" on the North American continent—"steep" walls—"wild" and uncultivated—remote and lonely. It is remote and wild, however, principally because it has little to offer.*

> *It is, in no sense, a spectacular gash, like the Grand Canyon of the Colorado.*

Another example of showing contempt and arrogance toward unspoiled lands was the battle to save the White Cloud Mountains in Idaho. It was a proposed open-pit mine that would be a mile long and several hundred feet deep. Lying just 30 miles north of the famed Sun Valley ski resort, the White Clouds were a pristine wilderness with

spectacular peaks but not protected from exploitation. A number of us formed the Greater Sawtooth Preservation Council to fight against this development. (The nearby Sawtooth Mountains were already considered for wilderness area protection, and adding the White Clouds to the legislation was our goal.)

With a writer friend and an assignment from *Smithsonian* magazine, I made a backpacking trip into the White Clouds to document what would be lost. The exploration supervisor for the mining company made a public statement that we seized upon because of its arrogance toward and ignorance of delicate mountain ecosystems: "Certainly we're going to make a big hole. We'll be removing tons of ore and rock, but it's our intention to do it with a minimum of disruption. What we can do is to re-establish the ecological system in the area to as high a value as it is now. We're sure we can do that. The landscape won't look the same as it does now. Maybe it might even be a little better."

The public outcry was so great that the mine was stopped and the area protected as the Greater Sawtooth National Recreation Area and Wilderness. However, the White Clouds, while part of the recreation area with some protection, did not receive complete protected status as a wilderness area until 2015—47 years after we took on this battle.

Use Black & White
We are used to seeing most imagery today in color. As a result, a black & white photograph draws attention. Use it. I've included this black & white image of a lion in many presentations to make a point: the African lion, that we used to think of as a secure species, is on the verge of being classified as endangered. In the 1980s, there were an estimated 200,000 lions across the African continent. Today, it's estimated that there are less than 20,000 because of loss of habitat.

Finally, think ahead. As a conservation photographer, your work can have historical value and serve as a benchmark to compare changes, good and bad, years or even decades later. Record as much information as possible in the metadata of the digital photos: date and time of the photo, place names, keywords and, if possible, GPS coordinates (many digital cameras can record GPS data; for others, there are add-on units to do this). Also, shoot lots and use various compositional arrangements in the photos, as you may never know how it may look years or decades later.

below. **A black & white image often attracts more attention because so many photographs we see today are in color. You can convert color images very effectively using Lightroom and Photoshop.**

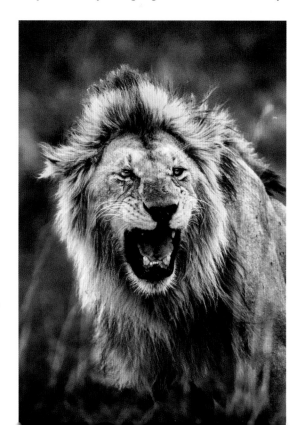

Wildlife

"The quicker we humans learn that saving open space and wildlife is critical to our welfare and quality of life, maybe we'll start thinking of doing something about it."

—*Jim Fowler, star of* Mutual of Omaha's Wild Kingdom *for many years*

As a conservation photographer, perhaps one of the most important factors in photographing wildlife is relating animals to habitat. This is important if you are involved in protecting a particular ecosystem threatened with destruction. Resident wildlife there is dependent on that ecosystem. It becomes a challenge, then, to portray this relationship in a meaningful way. A series of photos might do it: close shots of various animals, habitat photos of the region. A single photo, done well, can have significant impact.

We are always attracted to what might be called the charismatic *megafauna,* the large animals in a particular habitat: moose, elk, deer, grizzly bears, bighorn sheep, elephants, lions, etc. These are important, but don't overlook the small critters. In many ways, these are more challenging, but equally significant. A good example is the pika, a small rabbit-like mammal living above the timberline in high mountain country of the West. Pikas have been likened to canaries in a coal mine, warning us of the dangers of global warming. How? Pikas are adapted to very cold temperatures. Rather than spend a winter in hibernation, they harvest and store tundra grasses in rock shelters under deep snow and pass away the frigid season wide awake and happily feeding.

Warming climate, diminishing snowfall, and fewer grasses in the high mountains are forcing pikas to higher elevations—but when they've reached the tops of the peaks, there isn't anywhere else to go. They cannot migrate to a new higher mountain range. This is but one conservation story to be told.

top. The American pika is a small lagomorph (rabbit family) that lives in cold climate, high elevation habitat. Pikas have disappeared from more than $1/3$ of their previously known habitat in Nevada and Oregon. Because of declining populations, many researchers and conservationists are urging that pikas be classified as an endangered species. This one was photographed near the 14,000 foot summit of Mt. Evans in Colorado.

bottom. "Wait for me, Mom." This young polar bear is jumping to join the mother in the waters off Svalbard, Norway. 400mm lens used. A shutter speed of $1/4000$ second stopped the action nicely. Shot from the deck of a boat. Photo credit: Odalys Muñoz Gonzalez.

Undisturbed landscapes have at least two attributes important to most people: beauty and wildlife. There are other things of importance as well, such as watershed protection, recreation value, and air quality, but for many people, unspoiled nature is wild animals and scenic splendor. Polls have shown that wildlife viewing is one of the top aims for national park visitors.

As a photographer, you'll probably find it easier to document the aesthetic features of the place. Wildlife takes a little more time and patience. If the area you are documenting is near your home, you are probably familiar with the wildlife there. If it's a place in a distant region, then research is important. A simple online search can bring up a wealth of information. In fact, you may be surprised to learn about threatened species even in habitat you are familiar with.

Both universities and government agencies often have research data on various species. Spend time online looking at research projects. What species are protected? Do they need protecting? Are they in the process of being protected? Does anyone know about them? As you answer these questions, you'll learn which research groups are working with your subject matter. Not only can they help you get the inside action on an issue, but they can be an outlet for some of your photos over time. It is not unusual for conservation photographers to become citizen scientists.

Habitat is everything. We've been hearing in recent years of the melting ice in the Arctic and Antarctic. In the Arctic region, the ice pack is crucial habitat for polar bears. Polar bears use arctic ice to hunt seals, a primary food source. With warming temperatures, the sea ice is melting earlier in the year, and this forces the bears to shore before they have built sufficient fat reserves. They cannot hunt seals very well from shore.

Behavior

This is important, as it relates to environment and habitat. Some animals need space—lots of it. Perhaps the best example is the migration of wildebeest and zebras and certain other herbivore in the Serengeti and other ecosystems in Africa. Food and water are the driving force behind this migration. This creates the behavior pattern for moving on.

Many people are not aware of it, but we have significant wildlife migrations here in North America. These migrations include deer, elk, bison, and hibernating snakes (including rattlesnakes in the Northeast). Perhaps the least known has been the migration of pronghorn "antelope" (they are not a true antelope, but a distinct species). Having been hunted for centuries, they are notoriously shy animals, and documentation of their movements has been very difficult. However, recent technical developments have made possible photo documentation through the use of camera "traps," remote self-triggered cameras.

One of the best-known experts in using this technology is a young photographer named Joe Riis. Joe was trained as a wildlife biologist. He is now a full-time photographer and a National Geographic Photography Fellow.

"I'm a South Dakotan, a lover of wild places, and an adventurer in search of wildlife stories that inspire people to leave room for wildlife to roam. I strive to blend

science and field biology with photography and environmental conservation," Joe says.

When Joe began his pronghorn project, he recognized the difficulty involved. "Because of predators and hunting, you can't get close to them. I'm not a gear guy, but I realized that camera traps were the only way to document their movements."

The pronghorn migrate in the fall from Jackson Hole to the upper Green River basin wintering ground, covering about 120 miles. They must negotiate fences (they don't jump but have to crawl under them, if possible), a major highway, oil-drilling rigs, and swim across the Green River. In the spring, they reverse the migration. For the most part, they are in remote, wild country where Joe set up to document them.

There are commercial camera traps available, but these, for the most part, have some limiting features—fixed lenses and cameras of lower resolutions than DSLRs. Joe needed to use regular DSLRs with interchangeable lenses. Some of the camera housings were designed and built by the National Geographic Society. Some other units utilized point & shoot cameras, and one had a GoPro.

Joe had a limited supply of camera traps and had to place them carefully. For this, he worked closely with researchers and used their GPS data gathered from radio-collared pronghorns. In addition to the animal shots, he felt it necessary to simultaneously record the background environment to show the habitat. He used Nikon 7100s with 10–24mm zoom lenses, with a Trailmaster 1550 infrared, motion-sensing trigger and Nikon flash units, all in specially built weatherproof housings. Placement of the cameras was a tricky process. Joe had to study carefully the migration data and find paths that the pronghorns might take. The camera then had to be situated in such a way so as to record not only the animal(s), but the surrounding habitat, too. Usually, the cameras were set at or near ground level. It still remains a chancy process, and a lot of luck is involved. "If I get one or two great shots a year, I feel good," Joe says.

He *did* get great shots. Over time, he compiled a remarkable record of pronghorn movement and their terrain and habitat. Many of his photos have been featured in *National Geographic* and numerous other important publications.

Water Habitats

We tend to think of water supplies tainted by chemicals and other contaminants solely in terms of human health hazards, but

left. Joe Riis has become an expert in remote camera usage. These migrating pronghorns are in a remote area of Wyoming's Gros Ventre Mountain Range. He captured the annual migration from Jackson Hole to the upper Green River basin wintering grounds. Photo credit: Joe Riis.

right. Joe is a foremost expert on placing and using camera traps to capture shy and difficult-to-photograph wildlife. This photo shows pronghorn crossing the Green River. Photo credit: Joe Riis.

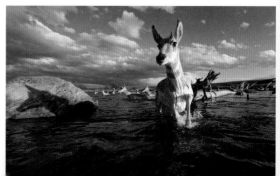

top, center, and bottom. **Salmon such as these, photographed with an underwater camera, migrate by the tens of thousands up the vast network of streams and rivers in Alaska's Bristol Bay region. Not only do these fish fuel a $1.5 billion economy for people of the area, but the salmon are a major food source for Alaska's brown (grizzly) bears. A proposed massive open pit copper and gold mine, with its polluting tailings and runoff and processing, will have major detrimental impact on the migrating salmon. These three photos are only a part of the story.**

wildlife is affected as well. Wildlife biologists are fearful of a uranium mine placed in and near the edge of the Selous Game Reserve in southern Tanzania. The Selous is the largest game reserve in Africa—so large that controlling elephant poaching has been a problem. The uranium mine can have a serious impact on the whole food chain, as the waste products from processing, radioactive and toxic, can leach into streams flowing into the reserve—and water is a vital component in any ecosystem.

In North America, water quality and pollution are serious issues. In Alaska, as in other places, there is a close link to healthy wildlife populations with water quality. Grizzly bears (also called coastal brown bears in Alaska) are reliant on healthy salmon migrations, and certain proposed mining operations can have a serious impact on the salmon population from toxic pollutants in stream systems. Currently, there is a major threat to the Bristol Bay region of Alaska. Bristol Bay salmon fisheries, through controlled harvesting of the migrating salmon, are a sustainable economic powerhouse for local communities and the lifeblood for Alaska Native cultures who have lived there for millennia. These produce an enormous portion of the world's sockeye salmon catch and one of the world's largest Chinook salmon runs, fueling 14,000 jobs and Alaska's $1.5 billion fishing economy. At the headwaters of these salmon streams, a huge open-pit copper and gold mine is planned. It's called the Pebble Mine, and its impact on not only the salmon, but other wildlife in the region, will be enormous.

Don't assume that wildlife species that appear to be common are not threatened. Case in point: in my 35 years of traveling in Africa, lions had appeared to be thriving until recently. They've always been seen in

great numbers throughout places such as Masai Mara Reserve in Kenya and Serengeti National Park in Tanzania, but the terrible truth is that across the continent, the lion population has plummeted. In the mid-1980s, it was estimated there were 200,000 or more throughout Africa. Today, that figure is estimated to be 20,000, and some experts think even less than that. The reasons for the decline are habitat loss, destructive developments, and human encroachment and settlement. In addition, a growing amount of poaching is taking place because lion bones are now in demand for replacement of rarer tiger bones in parts of Asia where such things are used in ridiculous folk medicines.

Ethics in Wildlife Photography

Photographing animals in the wild can be both frustrating and rewarding. In some of our national parks, species such as deer, elk, bison and, in Alaska, even grizzly bears have become habituated to the presence of humans in their midst. That does not mean they are tame, however. More-

over, they are still subject to stress from human pressure. When you are photographing wildlife, learn their body language—especially as it applies to reacting to your presence. It can be obvious in most cases. If the animals seem stressed, back off. The welfare of the animal should be paramount.

this page. **These photos represent the storytelling aspect of this major conservation issue. They depict a renewable resource (salmon) and reliance of indigenous and other Alaska residents on a subsistence food supply that is sustainable. If the Pebble Mine is built, it is predicted that these major salmon runs, among the greatest in the world, will be hugely impacted by the mine. Both people and wildlife will suffer.**

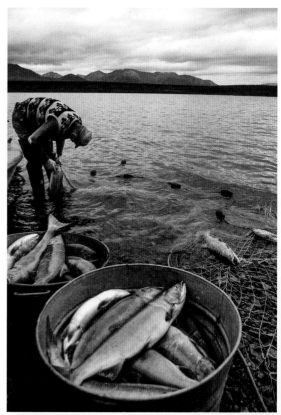

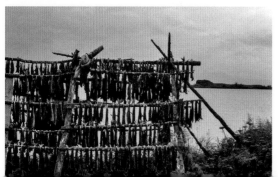

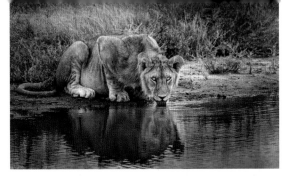

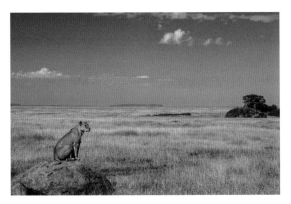

SERENGETI
The Eternal Beginning
Boyd Norton

top left. A young male lion drinks from a water-hole in Serengeti National Park in Tanzania. He's lucky, because as long as Serengeti remains a protected place, he may live to maturity. However, even this iconic national park is under threat by ill-conceived developments taking place.

bottom left. This photo symbolizes the plight of predators at the top of the food chain should the migratory herbivores disappear. A lone lioness looks for her next meal across an empty land-scape. The loss of certain keystone species can unravel a whole ecosystem.

top right. Why did we choose this picture for the cover of my Serengeti book? Think about it. Rhinos are critically endangered—near extinction in the wild. They are being killed by poachers at an alarming rate across Africa. I have hundreds of rhino photos, many of them up close, but this photo taken at a distance imparts a sense of loneliness and solitude against a vast land-scape. Subliminally it asks, "Are these the last two rhinos left on earth?"

Any institution that exploits animals solely for profit should not be utilized or supported. There are so-called game farms that keep animals in cages and release them for groups of well-paying photographers. Between photo sessions, these animals are often kept in tightly confined cages, and in some cases, under cruel conditions. The species include mountain lions (cougars), bears, bobcats, and even Siberian tigers! Don't support these traffickers in animal mistreatment.

• Don't overlook the small critters.
• Try to relate threats to the habitat with the inhabitants of the area.
• Keep careful records of where, when, what the animal is.
• Include important information in the metadata of the image, including GPS coordinates if available.
• Do research on the area you're documenting. Rare or unusual mammals or birds? Threatened or endangered species? Where possible, relate the wildlife to its environment.
• Contact and work with researchers. They can use your help and vice versa.
• Poaching and habitat loss are not the only threats to wildlife. The pet trade alone can cause drastic loss of certain species.
• Keep in mind that people are very often part of a wildlife conservation issue you may be documenting. Damage to the economy and loss of food and jobs are part of the story.

Saving African Wildlife

Photo credit: Tessa van Schaik.

I first met Ian Michler at the 10th World Wilderness Congress held in Salamanca, Spain, in 2013. I helped to organize some writing seminars for the International League of Conservation Writers to be conducted during the congress. One of our invited presenters had to leave unexpectedly, and Ian agreed to fill in just before the sessions began. His presentation was greatly received and had an enormous and heart-wrenching impact on the audience. With his words and images, he discussed the plight of "canned lions," cats that were bred and raised for a bullet from rich hunters in a closed environment. Ian's Blood Lions *is an award-winning feature*

documentary film, and even if you just watch the trailer on YouTube, I guarantee that you will be angered by what some people are doing to this noble animal.

Ian's additional work in southern Africa and other parts of the continent is in the protection of habitat and migration corridors for wildlife.

Ian Michler, in his own words:

"The adage 'a picture is worth a thousand words' may well carry even greater significance today than it did back in the early 1900s when first used in the advertising world. As we struggle with the urgent need to convey a message of a different sort, one that deals with a host of environmental and social crises across the globe, these words serve as encouragement to the powerful impact imagery can have when telling these stories.

"On reflection, the hard truth for us as photojournalists and writers to swallow is that whatever we are currently doing, individually and collectively, in telling the world about the state of our planet, we are not doing it well enough. I say this because the research and science are very clear; whether measuring global warming trends, poaching levels, deforestation and biodiversity loss, income inequality, unemployment, or religious intolerance, for example, these natural and social indicators show how humanity's living patterns continue to wreak havoc on the environment, and that our communities seem to be ever more polarized and conflicted. Most tellingly,

despite our best efforts, we have not been able to facilitate behavioral change in any meaningful way.

"Regardless of the complexities involved, the message to get across remains a straightforward one: the way we currently live is not sustainable. The planet is no longer able to meet our demands for resources or replenish the damage we inflict. In addition, the way economic and social benefits accrue results in inequality and polarization.

"For the younger generations, the reality is even crueler; it's taken us hundreds of years advancing on what we like to call *development,* but this progress in many fields may well be wiped out for them in a single generation by the negative environmental and social consequences.

"As storytellers, our challenge today is to convey the magnitude of the situation along with the substantial repercussions if we continue to ignore or deny the science. In doing this, we must seek to somehow link individuals and communities to the issue being portrayed in a manner that forces them to ask questions of themselves. In the end, we need everyone to reflect on how we feed into the challenges we face,

and how can we change in order to make a difference.

"Of course, using the written word will be vital, as this form allows us to tease out the nuances and work with the complexities that create the space to debate opinions and options. However, the power of photography, a medium that lays out the visual narrative, will likely be the most telling. An effective image can be like a blow to the solar plexus, so persuasive that it demands our immediate attention. With the harshness burning back at our gaze, we are compelled in that immediate moment to reflect and consider, to absorb the enormity of what lies before our eyes.

"My call is for more strident images, ones that speak more loudly about the severity of the degradation and the losses and expose the inequality. Nice, sanitized images of wildlife in scenic landscapes are important, but we also need to see the ugly reality. The world over, history holds images such as these, the ones that have made such a shocking impact that they have managed to alter opinion and move decision-makers to action, as moments of change.

It is an inordinately onerous challenge, but one that I believe we are obligated to

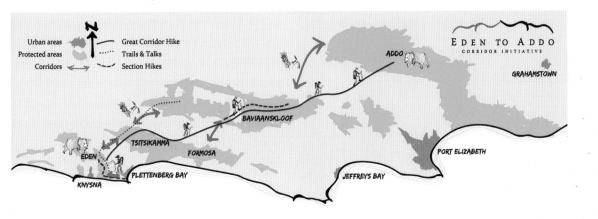

undertake. My work takes place at several levels. Firstly, in conservation, I believe habitat protection to be the most important aspect. Within protected or flourishing habitats, species will breed. Without habitat, no amount of breeding in captivity makes any sense. In this regard, my work with Eden to Addo (www.edentoaddo.co.za), a corridor initiative linking three large protected areas in South Africa, is vital for the future of these landscapes.

"Secondly, at the biodiversity level, caring for the future of specific species assists entire communities of creatures and the ecosystems, and doing this through

the plight of individual animals can also be effective. This is why my documentary *Blood Lions* (www.bloodlions.org) has been so important; it deals with the welfare considerations as much as the collective conservation effort of lions. I started my work on predator breeding and canned hunting during the late 1990s. Back then, most of this was through articles and opinion pieces, but I got little traction. The real impact only came later with the power of imagery through film and photography. These mediums were able to penetrate the lies and misinformation and translate the horror of what was taking place in a way that lead to action.

"Lastly, like all of us doing this work, I work as an educator, a sphere that is essential to facilitating change. Ignorance and a lack of awareness plays a fundamental role in the destruction of the environment and discrimination against others. The Tracks of Giants (https://tracksofgiants.org/) project addresses the continent's conservation challenges, while through Invent Africa (www.inventafrica.com), my safari operation, we introduce people to the many wondrous wilderness areas across Africa as well as the continent's immense and vibrant cultural diversity.

"My wish is that every photographer, every storyteller in their respective field, goes out there and, more than ever, tells their story in the most vivid, shocking, and effective of ways. Be bold and brave enough in the telling that your story demands of us that we transform the way we live."

top and bottom. **These caged lions, barely able to move around in their confines, could have ended up being shot by rich hunters. Canned hunting is all about being bred for a bullet! Photo credit: Ian Michler.**

Video

"There are no rules for good photographs, there are only good photographs."
—Ansel Adams

My first involvement in photography began with cinematography. After college, as soon as I could afford it, I bought one of those big Bolex movie cameras. The camera was designed for 16mm film, but this particular version was adapted for 8mm shooting (much cheaper than shooting and processing 16mm). I toted that big camera with me on backpacking and climbing trips (along with my still camera) and shot lots of footage. I learned cinematography techniques by studying books that were available then.

As I became more involved in protecting some of these places against threats, I realized the movies were not very helpful. First, long before the Internet, you could not reach the necessary broad audience you could with still photos published in magazines and books. Also, 8mm was not of high enough quality to show in theaters.

In addition, editing was very labor intensive and time consuming—cutting the film and rearranging these clips in a logical order to tell a story then splicing them together. Also, these were silent movies. To add sound—narration, music, voices—involved another layer of intensive work. And so, to fight my early conservation battles, I switched to still photography.

Today, it is a radically different situation. Digital video makes it possible to create some very high-quality documentaries with music and narration which have great impact. Displaying them to a large audience is easily accomplished on the Internet by way of YouTube and Vimeo. Moreover, every digital camera today, including your smartphone, has video shooting capabilities, so you've got great technology at your fingertips. Editing also has become easier, with great computer programs that allow you to arrange and alter clips, add transitions and fancier things, and add a music track or narration or both. Moreover, an effective short video can be put together in hours instead of days, weeks, or months for film.

Like digital still photography, digital video technology is changing rapidly. In the first edition of this book, HD video was the norm, at 1920x1280 pixels per image. Now we have 4K (4096x2160 pixels) and higher. Even HD is capable of giving reasonable quality images from frames lifted from the video file.

Balancing the two—still photography and video—presents a challenge, but having the two is extremely valuable in documenting a place or issues. Interestingly, video technology is advancing so well that, at times, you can use still images lifted from video footage.

Though the technology has changed dramatically, most of the important principles

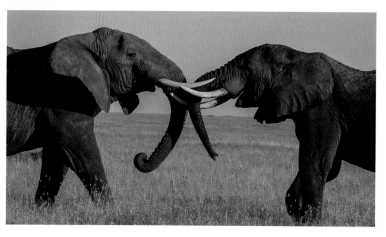

top. This still photo was lifted from an HD video clip shot with a Canon DSLR in Serengeti National Park. 4K and higher video can provide even better quality still photos from a video clip frame. If you plan to use still images from video, be sure that you steady the camera on a tripod, or in this case, a firm beanbag on the roof hatch of a safari vehicle.

bottom. Here is a simple way to outline your video documentary. LS = Long shot; MS = Medium shot, CU = close-up, VO = Voice over.

Shot List/Scene List

Shot	Scene/Subject	Location	Misc
LS	Jones Creek, stream flowing toward camera	Jones Creek entrance	title scene with overlay; natural sounds
MS	Family with 2 kids walking toward stream on trail	~ ½ mile from entrance, at bend in the stream	Audio: family talking from distance
CU	Quick shots, several; faces of parents talking, smiling, kids running ahead	Approaching scenic bend in the stream, framed by trees	Several shots, hand held, from low perspec; looking up; natural sounds
LS & MS	Parents walk up to kids sitting on large rock by the stream, take off rucksacks, sit with kids	Same as above, but looking back as parents approach camera	Maybe shot from other side of stream looking across; Audio – sound of stream flowing.
MS & CUs Series of several; show enjoyment of the place	Parents take out sandwiches from rucksacks, everyone enjoys eating while sitting and watching the stream	Series; different angles;	Begin narrative VO: *This is Jones Creek a small nature reserve enjoyed by many residents of*_____
Dissolve to series of previously shot scenes here;	Montage; deer walking through woods; drinking from stream; squirrels and chipmunks, birds in trees, frogs, toads, wind rustling leaves in trees,	Previous footage, various locales in Jones Creek park	VO: begin narrative on why Jones Creek needs to be saved from development.

Before you begin, think *story*. Filmmaking is storytelling. Documentaries tell a story. If you don't have a shooting script, be thinking about what your storyline is while you are shooting. It shouldn't be all scenery. People are a part of it. Include details: faces, activities, hands doing things like holding a camera, planting a tree.

If you plan to do a serious video documentary about your conservation project, plan it! Take the time to visualize the video from beginning to end. Watch other documentaries that you've enjoyed and see how they were done. The most important aspect before you pick up the camera is to have a shooting script, storyboard, or shot list. The shooting script or a simple shot list is perhaps the most practical.

The shooting script is simply a listing of short sentences that describe the scenes and subjects you want to include and in the

of good cinematography still apply. This chapter deals with these important principles and why shooting video should be approached with a different frame of mind than still photography.

There is one overpowering rule for video: *video is a horizontal format.* It drives me crazy when I see amateur video on the news shot with a smartphone held vertically. It's like looking through a tiny slit of a window and the rest of the format is missing to the edges. *Don't shoot video vertically!*

order in which you want them. Like a Hollywood movie, your documentary should tell a story with a beginning, middle, and end. However, you must tell your story in a much shorter time than a 100-minute Hollywood film. Do not even consider making a documentary longer than 10 or 15 minutes unless Robert Redford is starring in it. Shorter is often better, which makes it even more challenging. Basically, it's best to assume that your audience will have the attention span of a three-year-old.

Don't be dismayed by having to make a short film. I have seen many effective mini documentaries ranging 2 to 5 minutes in length. If you make a 20 to 30 minute or longer documentary, be sure to make a 2 to 3 minute trailer for it to give sufficient information to people who are interested and want to see your project. A very effective example of this is the trailer for Ian Michler's award-winning *Blood Lions* documentary (https://www.youtube.com/watch?v=-T86GCjCpus). It is 2 minutes long. In just 120 seconds, you learn a great deal about the horrific treatment of these magnificent animals. The full film is 1 hour and 24 minutes long.

Technique

When starting to shoot video with your camcorder, DSLR, DSLM, etc., keep in mind:

1. Get an establishing shot or shots; this could be a wide angle of a place, a sign, an entrance.
2. Capture middle or medium shots; move in closer to subjects or action.
3. Include close-ups—a tight shot of a face or a subject or hands doing something.

Detail

Having a variety of shots will make for good editing later.

If it's absolutely necessary to hand-hold the camera, use the viewfinder, *not* the fold-out LCD screen, and keep elbows into your ribs. This approach gives more stability for the camera. Using the LCD screen requires that you hold the camera away from your body, and this often generates shakiness when holding the camera at arm's length. Moreover, using the viewfinder allows you to better examine details in the scene for good composition. It's really better to use a tripod or monopod if possible. Watch the horizon line, too; it's easy to get it tilted when concentrating on a subject.

Don't zoom in or out unless it's for a very special effect. It is rare when you can zoom smoothly on camcorders and even tougher when you are using your regular lenses on a DSLR or DSLM. Better to stop the camera, zoom in tight on a subject, then resume shooting. Also, remember when zoomed in tight (telephoto shot) any camera movement is magnified. Better to brace the camera or use a tripod when shooting telephoto shots.

Don't pan unless it's to follow a moving subject; even then, it is difficult to do while hand-holding the camera. Panning a scenic shot hand held is often bumpy and visually distracting. Don't do it. Use a tripod with a fluid pan head. When using a fluid pan head, pans are best done *slowly*. A swish pan (moving the camera rapidly from one subject to another) is very tricky. Best to stop the shot, turn and focus on another subject, then restart shooting.

Image Stabilization

Having stated that the video should be steady, I should point out that many cameras today have greatly improved image stabilization. I have seen some amazing video footage done hand-held, and the stabilized scenes were remarkable. My advice: check out the image stabilizing features of any camera you intend to use for a lot of video shooting, and pick the best to use.

When working with a moving subject, instead of panning with it, sometimes it's best to let the subject enter and leave the scene, keeping a stationary camera. If you have the time, do both (i.e., pan with the subject, then do another shot with subject moving into and out of a stationary scene). It's good to have a choice when editing.

How long should a shot be? Answer: as long as it takes to make a point or establish a setting. While shooting, remember that it is better to have too much footage than too little. Scenes can be trimmed in editing, but you cannot add footage that you did not shoot. In addition, shooting digital video is infinitely cheaper than shooting with film years ago. Don't spare the electrons!

Framing a scene in video is very much like using good rules of composition in still photography. There is one difference, however: you may need to plan your framing in anticipation of movement—not movement of the camera, but movement of the subject. With people, you can plan and direct such moves, but with wildlife you have to learn to read body language and anticipate in which direction the animal may move.

As in still photography, light can establish the mood of a scene. Even if you plan to shoot a simple documentation of a place, the impact of lighting can be important in doing a good job. In bright sunlight, there can be problems with contrast. Very often video cameras tend to record scenes with more contrast than is desirable. For still photographs, the contrast can be easily adjusted in Photoshop or Lightroom, but it is much more difficult to do the same with video in postproduction. If you've ever watch a television news crew at work, you will have noticed that very often supplemental fill lighting is used on subjects by means of reflectors.

Editing

When shooting film, the process of editing involved the literal cutting of the film and splicing together scenes of the proper length in the proper order—an onerous task even in major film studios. Digital video's great advantage lies in the capability of using a computer to edit.

This is the really creative part. Here is where you

below. A viewfinder is very important when using your DSLR for video. It not only gives a magnified view of the LCD screen but also blocks outside light and makes it easier to compose the scene, especially in bright sunlight.

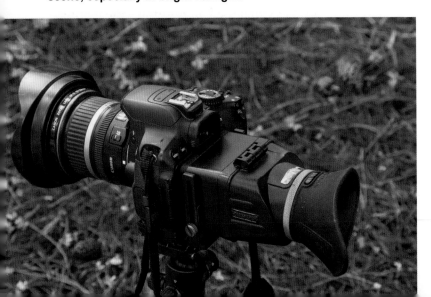

become a composer and create a symphony of sights and sounds for your video story. Instead of cutting film, you, the creative video editor, trim video clips in the computer, place them in order on the time line, and establish a flow for your production. You also add voice to create a complete story and music to set a mood.

There are numerous video-editing programs available, ranging from high-end pro versions to inexpensive consumer versions. Nowadays, even the inexpensive programs are capable of producing very sophisticated video with special effects, narration, and music. Most have very similar features and layout: a video time line (with sound recorded at the time of shooting), additional tracks or time lines for adding music or narration, and other tracks or add-ons for special effects. Some of these effects include stop-action (freezing on one frame), slow motion, sped-up motion, and more fancy visual effects. Just be careful and don't overdo it.

Many of these programs have been improved greatly in recent years, and the learning curves have shortened considerably. It is well worth it to learn video editing and use it to get your message out there in an entertaining way.

Practice!

When you've finished your production in the computer, you will want to share it with others. You can burn a DVD or upload the video to YouTube or Vimeo, Instagram, or your own website.

Interviews

There will be times when you need to interview people for your video presenta-tion. Good interviewing technique takes practice. The people on *60 Minutes* make it look easy, but it's not. It takes training, experience, and skill.

First and foremost, do not rely on the camera's built-in microphone—especially if it is outdoors with wind and other background noises. It is worthwhile to invest in a wireless mike system, also called a lavalier. I've found that even a less-expensive system (under $150 for a set consisting of wireless microphone, transmitter, and receiver) works far better than the built-in mike.

Think through beforehand and ask questions that will help build your story. If your interviewee is someone fighting to save a place, ask how (and why) they got started. A researcher might describe his or her work and add information about how important it is to save this place or species. Build your story from there by asking relevant questions.

Videos featuring interviews need to be done carefully. Talking heads can become boring very quickly. Often, however, you can use the voice of the interviewee in a video showing the area or species under threat. Conversely, if the person interviewed is compelling enough, a series of still photos or video clips can be overlaid on the video track to minimize the talking head syndrome and add visual interest.

Video has become an essential tool for conservation. This chapter is only a brief overview of the topic. You should study how video has been used by other photographers by visiting their websites. The web addresses of the photographers profiled in this book are listed in the Resources section. Study them and learn.

Get Organized

"Never doubt that a small group of thoughtful, committed citizens can change the world; indeed it's the only thing that ever has."—*Margaret Mead*

Until now, I've covered some of the nuts and bolts of creating strong photographs. Let's concentrate here on the nuts and bolts of serious involvement in the conservation part. This has to do with working with conservation organizations or possibly creating your own organization.

The Sierra Club has 63 chapters throughout the country. The National Audubon Society has nearly 500 local chapters or affiliates in various regions and states. Becoming a member of one or more of these organizations can be a great aid in your conservation work. In fact, it would be well worth your time and expense to join and support as many of these organizations as you can. Most have print and online publications that keep you apprised of current conservation issues. These publications also can be a very effective way of displaying your work and alerting others to your conservation issues. More importantly, if you are involved in your own conservation battle, members and staff of these organizations can provide vital advice and support. Finally, having the backing of a large, national organization for your fight gives you greater credibility.

Of particular importance is that you can gain benefit from the experience and expertise of, say, the Sierra Club. Members and staff of the organization can give

you good legal insight and even help draft protective legislation and offer advice on getting representatives to introduce the bill.

The downside to having your battle associated with a large national organization is that there may not be a local chapter or affiliate near you to work with. Working with the national office of these organizations can be time consuming. As you can imagine, the Sierra Club, Wilderness Society, and others have a lot of large issues to deal with, and your own issue may not be of very high priority for their staff.

Organize your own group? There are some advantages to having a separate organization for a specific battle. First and foremost is name recognition. The place you are working to preserve should be in the name. This can help attract local and regional attention. Having your own organization does not preclude working with the big, national conservation organizations. In fact, it helps because it shows that your cause is attracting both local and regional concern, and you get the benefit of the national organization's expertise.

When we fought the battle to stop the dam in Hells Canyon, we founded the Hells Canyon Preservation Council (HCPC). "We," it turns out, were only seven people. Here's how seven people stopped a project that was close to starting

left. Famed folk singer Pete Seeger joined us on our five-day raft trip and serenaded Hells Canyon with a song he wrote about the place.

top right. The author, Boyd Norton, rowing the raft. Photo Credit: Larry Williams.

bottom right. The author seated next to Oregon Senator Bob Packwood on a five-day raft trip in Hells Canyon. The CBS News team is in the background. When you are seeking protective legislation for a place, it's important to try to get legislators to visit that place personally. If that's not possible, do your finest printing job with your best photos to show to legislators. And be sure to have a written summary of the land features and the kind of protection you are seeking—state park, national park, wilderness area, wildlife reserve, recreation area, etc.

and went on to get legislative protection through Congress.

We didn't do it alone, however. The biggest help came from the Sierra Club's northwest representative, Brock Evans. Brock, then a recent law school graduate, jumped into our battle right away by filing an intervention on our behalf with the Federal Power Commission. The commission was to rule on granting a license to the power companies to build the dam. Our formal intervention was intended to build a strong case for *not* building it. We soon began conducting a number of "show me" trips to get press people involved. At first, it was local and regional reporters. Later, we were able to get a writer from the *New York Times* and from *Life* magazine.

In this time period, one of the most popular television and radio entertainers was Arthur Godfrey. He had daily radio programs reaching millions and a weekly television show. On a whim, I wrote a letter to Godfrey inviting him on one of our show-me trips. I never expected a response, let alone an acceptance. A month later, I received a letter from him saying he would be delighted to visit Hells Canyon.

Godfrey's account of his trip reached a large national audience on his radio

program. He returned the following year and brought with him then Secretary of the Interior Wally Hickel. This trip also resulted in widespread publicity for our cause.

A few of us from the Hells Canyon Preservation Council attended and testified at the first Senate hearing on the bill to protect Hells Canyon. Arthur Godfrey also testified and, because of his fame, drew a large number of television and press reporters to cover it. The publicity for our battle was growing, and Hells Canyon was transformed from a place no one knew into one that was now recognized as one of America's scenic wonders. However, it took more years of hearings and deliberations before our bill was passed.

In 1972, I took Pete Seeger on a six-day whitewater raft trip there, and this furthered publicity for saving the canyon and river. In 1974, the CBS News team joined us on another raft trip, this time with Senator Bob Packwood. Since he was the Senator from Oregon, Packwood took great pride in protecting Hells Canyon, partly because it was in Oregon and partly because he experienced the wonders of the place firsthand.

On December 31, 1975, the Hells Canyon National Recreation Area bill was passed by Congress and signed into law. The dam was halted, and Hells Canyon was saved. It took eight years from the time we started the fight, but it was worth it.

Protecting the Protected

Not every threatened place is famous, but that should not deter you from using whatever means possible to save your favorite piece of wild land. Do not underestimate the power of your own photography in showing the world the wonders and value of threatened wild lands. A good example

this page. Conservation photographer Jim Griggs works with and helps to maintain the small Maxwell Wildlife Refuge near McPherson, KS. He documents the wildlife here and donates the photos for the refuge's displays and brochures. In addition, Griggs also conducts photography workshops and donates a portion of the fee that people pay. Photo credit: Jim Griggs.

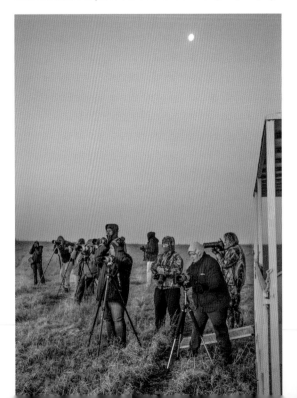

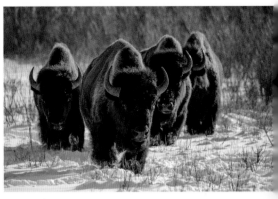

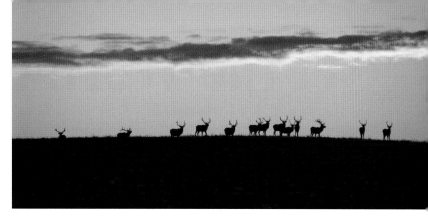

of a little-known place being saved and maintained by photography is the Maxwell Wildlife Refuge near McPherson, KS.

Never heard of Maxwell? It's not as famous as Yellowstone or Serengeti, but this small refuge (2800 acres) is important for protecting a part of some native prairie lands and the wildlife it supports. Descendants of an early settler, Henry Gault Maxwell, deeded this land to the Kansas Department of Wildlife and Parks (KDWP), which created the refuge.

Professional photographer Jim Griggs, who lives nearby, has made Maxwell Refuge a project of his to maintain and promote its values to the public. He donates his photos to the refuge in order to promote it. In addition, Jim conducts photo workshops there, and fees from these help to maintain the refuge. His role points to a need for many areas that have some degree of protection, but without funding, the land and the wildlife might be degraded over time.

You have to get involved; taking pretty pictures is *not* enough. Organize to fight a particular battle. Join a conservation organization fighting a battle or form your own local group. Donate use of your photos to groups that can't afford to pay. Most often, conservation issues involve hearings— some on the local level, some regional, some national. Your photos make you an expert. Testify at these hearings and use your photographs to show what should be saved and why.

You can make a difference:

- Define your mission. What are the threats? What are the benefits of preserving/protecting? Are there endangered species?
- Organize. Enlist the aid of friends and/or family. Give your organization an appropriate name.
- Contact local and national conservation organizations and express your concerns (see the Resources section for a list of national organizations). Send a summary, photos, and maps of the place and the threat(s).
- Publicize on social media, local news media, and national news media (if you feel it's of national importance). Use your greatest photos.
- Give presentations to clubs and organizations.
- Conduct show-me trips for interested citizens, local media, clubs.
- Make contact with, and/or visit, local politicians—county commissioners, state representatives, national representatives.
- Attend and testify at any public hearings held on the issue/place. Urge friends, family, and others to do the same.
- Start an email campaign to have others send emails supporting any legislation that will protect your place.

Get the Word Out

"Photography is a small voice, at best, but sometimes one photograph, or a group of them, can lure our sense of awareness."—*W. Eugene Smith*

What next? After the pictures are taken and processed, you need to get them out there so people can see and react. In your work as a conservation photographer, you will be challenged to find ways to reach the people who do not necessarily feel as you do about protecting nature. Not everyone is a nature lover, though they may be amenable to your message if presented well and properly. Let's look at some ways to reach an audience.

In the previous chapter, I discussed the benefits of working with existing conservation organizations. Many of these have publications, both in print and online, and these are an excellent way to showcase your work and get your message across. If you've been working with representatives of an organization, use these contacts to gain access to publications. In submitting digital work, find out the preferred format for publishing—usually a high-resolution JPEG is needed, normally at 300dpi for print publications. For online use, a lower resolution is the norm—usually 72dpi. Preferred pixel dimensions may vary, but usually it is 4000 pixels in the longest dimension for print, smaller for online.

When submitting to a publication, more is not necessarily better. Most editors prefer a tight edit, so don't submit a lot of similar pictures of the same scene or subject.

Obviously, it should be your best-quality work. It's tough to edit your own work sometimes, but to help in that process, keep the story in mind. Do the pictures reinforce the story of what the place is all about and what the threats are to it? Try to picture yourself as a reader or viewer trying to understand what it's all about.

Print Exhibitions

Exhibitions of prints are also a good option, though fewer people might see your work and react to your message. A good exhibit can be expensive to produce and promote unless you can get it underwritten by a local business or organization. Consider the time involved in making the prints (if you do it yourself) or the expense of having the prints done by a lab. Matting, framing, and hanging the exhibit is an added expense unless you find an underwriter. On the plus side, you may sell some prints to defray some of your expenses in shooting and creating the exhibit. Sales of prints can be a good way to raise funds for your own or a national conservation organization. If you go the exhibition route, I recommend working with businesses and organizations for sponsorship. If you are a good salesperson, you may convince one of these entities to put up the money for an exhibition by pointing out the good and

positive publicity from such sponsorship. It has happened in the past, and it continues to be one way to attract attention to a conservation issue.

Presentations

Media or slide presentations can reach a large number of people over time. A great many civic and social organizations are in need of programs for their members. The same is true for camera or photography clubs. Contact them and make yourself available. Powerpoint and other programs make it easy to create effective digital slide presentations. You don't need to be a great public speaker, but with practice you can become very good at it. Here are a few tips:

- Keep your message simple. True, the issue you are dealing with may have a lot of complexities, but it's often not necessary to go into such detail. Hit the high points. Use your best images to highlight the beauty of the place you want to save.
- Use maps as well as photos. If the place is little known, it's best to let the audience know where it is, and perhaps even encourage them to visit it. Google Earth is a very useful tool in showing the locale. It's easy to create a slide from a screen capture of Google Earth.
- Don't rely on using the Internet for parts of your presentation. First of all, you can never be sure of good Internet connectivity where you'll be presenting. Moreover, if you have to stop your presentation in order to connect and find the material you want to show from a website, it will really slow down your show.

Over many years of doing presentations, some at very big international gatherings, I've learned that humor in small doses helps keep your audience with you. As an audience warm-up, I sometimes poke fun at myself and my profession, using a silly

below. This exhibition featured photos by the International League of Conservation Photographers. It was sponsored by Fine Print Imaging and displayed at a Fort Collins, CO, gallery, The Collective. The number of people viewing exhibits may be far fewer than an online collection, but often the people who attend exhibitions are interested, influential, and may be of help to your cause.

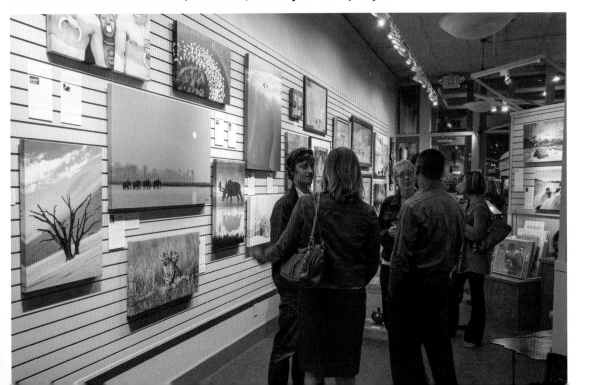

passion over the cause turn off an audience. I find it very effective to maintain a low-key tone in my presentations and let my photographs carry the message.

In addition to still photos, I use video clips to liven up the presentation. Be careful that you don't make the videos too long; use them for short interludes between slides—10 to 12 seconds unless the subject matter is really compelling.

Giving effective presentations is an art form, and you should practice making your programs entertaining and informative. Also, be flexible in timing your program. Some organizations and events have strict rules on the length of presentations, so you need to be able to add or subtract material to adhere to those rules. Even when there is some flexibility in program length, keep in mind that more is not necessarily better. Unless you are an experienced entertainer, it is hard to keep an audience interested when your program exceeds 30 or 40 minutes in length. In addition, I always plan my programs to allow enough time for questions and audience interaction afterward. In many cases, this Q & A period helps to engage the audience, and often you will find strong supporters of your cause.

Short programs can be a challenge. At the 10th World Wilderness Congress in Spain in 2013, all plenary presentations were limited to 15 minutes. I was invited to speak on our battle to save the Serengeti ecosystem, and I had to make my presentation contain the most important information

photo I made years ago using some borrowed cameras. I have a file of silly sign photos to warm up audiences, too.

In giving presentations on conservation issues, there is always a danger of becoming too strident and losing the support of your audience. Saving wild places is an emotional issue, but it's best not to let our

without rushing through it in the allotted time. My photos were chosen carefully, and I got double duty out of some by overlaying wildlife population information.

Many presenters use Powerpoint text slides loaded with bulleted stats and hard-to-read information. I can't think of a better way to lose your audience. If you feel it is necessary to show some facts and figures to help people retain the information, get creative. Use some of your best photos with overlays, but keep the information on the overlay to a minimum. One of my most effective statistical slides uses one of my favorite African lion photos—several lionesses and cubs lined up drinking from a waterhole. The first slide (usually on-screen for roughly 5 seconds) has no information, just the lions drinking. The second has the shocking information at how rapidly Africa is losing its lions. It never fails to elicit a reaction from the viewers.

Pacing

This is very important. If you show every slide for exactly 12 seconds or find it necessary to explain a picture for minutes at a time, you will hear snoring in the audience. Think of your slide presentation as a symphony and yourself as the conductor. You may begin quietly and slowly build to a climax in the presentation. Some slides may warrant absorption and appreciation for their beauty. Some may be fast-paced—a sequence of action, for example. You may very well show some scenes of destruction, and they can be shown at a faster pace than the scenes of quiet beauty. Vary your presentation in such a way as to pull your audience in to your message visually and audibly as you talk.

Tailor your program to fit the audience. Obviously, you would not give the same presentation to an older audience as you would to grade-school kids. When I give programs to conservation organizations, I'm careful not to tell them things they already know about an issue. For general audiences, I always assume that they are there to learn something from me about this particular issue, but I also recognize that many, if not most people, don't have the same passion for my conservation project. So I try to make my program entertaining enough to generate some passion and interest on their part.

I used to hate changing my presentations. This was back in the time when we used carousel slide projectors. Every program used one or more of those carousel trays with a slide in each slot. To make changes meant taking out most or all of the slides and adding or rearranging them on a light box, then putting them back in the tray in the proper order (and hoping that they weren't backward or upside-down).

left and right. **Keep info slides simple. If you cram too much text on them, they will be hard to read.**

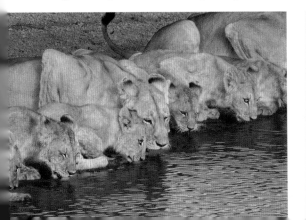
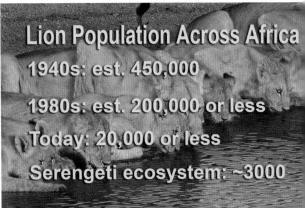

Today, it's all done on a computer screen and it is easy enough to rearrange or add new material. So, keep your program active and lively and tailor it to fit the audience with the appropriate images. If you find yourself doing lots of presentations, you may want to save several versions of the program, long and short, to save preparation time.

Finally, practice, practice, practice. Know what you are going to say and how you will say it. Reading from notes is deadly boring. Avoid it if at all possible.

Every program I give is done extemporaneously, with no notes whatsoever. I never know exactly what I am going to say, but I know my topics well enough to keep the programs flowing smoothly.

Giving presentations is very time consuming, but very often the personal interaction with people in the audience has led to strong supporters for the cause. This has ultimately led to their involvement and, sometimes, engaging people who have expertise in fields in which I had none.

The Internet & Social Media

There are other effective ways to get your message out there, the Internet being the most obvious. In my earliest conservation battles, there was no Internet. It took a great deal of time to make news media contacts via snail mail, and it took even more time to get articles and photo essays published. Months, even years, were spent garnering support and lobbying for legislation. In retrospect, it seems miraculous that we could win some of those battles because of the slow pace.

Today, when time seems to be crucial in stopping threats to wild areas, social media is one way to elicit some rapid responses and perhaps some action.

In addition to using social media, websites and blogs are also effective. You can post on Facebook or Twitter or LinkedIn some page links to a website or blog to inform people about your cause. A good blog or website can be a great showcase for your photographs and video. In using a website or blog, you should, of course, make it clear how viewers can help and become involved, even if it's nothing more than signing a petition.

Magazine & Book Publishing

There are a great many online magazines these days, and a significant number are devoted to environmental subjects. A Google search for "online environmental magazines" yields dozens of listings. Some are newsletters and some are online versions of such print magazines as *Audubon*. Before making a submission, you'll need to find on their website information on how to submit photos and/or stories. To avoid being deluged with submissions, that information is often buried deep on the site, and nearly all publishers will request that you query before submitting anything. You'll need to be patient; the process of querying and submitting can take a lot of time.

Your odds of getting your photo story published are greatly enhanced if you develop some writing skills. Even providing extensive caption information for your pictures can enhance your publishing chances. In fact, I have advised photographers for years that should they develop good writing capability. It doesn't have to be flowery prose—in fact, it's better that it's not. But you should be able to tell your

conservation story succinctly, compellingly and accurately.

Book publishing has changed dramatically in recent years. I think every nature photographer aspires to have a coffee-table book published with his or her best photos. It's not likely to happen through conventional publishing houses unless you have a story of very widespread appeal and lots of outstanding pictures, plus a publishing track record.

With the ease of self-publishing now, it may be a good route for getting your message out there—but don't expect much of a monetary reward for your efforts. A well-done photo book 8x6 inches, soft cover with 20 pages of photos and text and printed through companies like Blurb, Snapfish, Shutterfly, or My Publisher can cost $20 or so per copy. In larger quantities, the price per copy drops by a few dollars. These self-publishing companies make it very easy to put together eye-catching layouts using templates. Dropping in blocks of text is also easy. With care, you can produce an outstanding publication of your work.

There are two major benefits of self-publishing a book on your cause. One is to use it as a fundraiser for conservation efforts, the other is to use the book as a giveaway to decision makers—legislators, representatives, senators. A 20-page book, done well, can covey a lot about the habitat and wildlife of a place you are working to save. You can, of course, create more pages or do a larger-sized book, but the cost goes up accordingly. As I suggested in my section on print exhibitions, you may be able to find a local or regional business to underwrite the cost of publication. This could also be valuable to the business by offering to have a page giving credit to them, perhaps with a photo or two promoting them.

News Releases

One advantage to starting your own organization, with a name that includes the place you want to preserve, is that news releases will attract more attention than if you simply send a news item under your own name.

Keep in mind that creating news releases is an art form. Shorter is better. Keep it succinct. Two- and three-page news releases don't get read. If you are not comfortable writing it yourself, get some help from someone who is good at writing clearly. Also, don't send out news releases unless there's something newsworthy—an upcoming hearing, or the outcome of a hearing just completed, or an item about some new species discovered in the place you want to preserve, or, related to that, some new photos of a little-known creature in residence there.

Keep in mind that for a successful PR pitch there are five Ws: *who, what, when, where,* and *why.* Be sure you include each one in your news release.

If you have just started your organization, that is newsworthy in itself—especially if you have gotten the support of a large group of people who also want to save your place. It is rare that a media outlet will run just a news release. Contact information should be in the heading of the release. If you do attract attention, be prepared for an interview by a news reporter, maybe a local television station. All this is worth the effort because it can gain more widespread support for your cause.

Conservation Wins

"... the people who are crazy enough to think they can change the world are the ones who do."—*Steve Jobs*

Amy Gulick

Amy Gulick is a professional photographer and writer whose work has appeared in Audubon, Outdoor Photographer, National Wildlife, Sierra, *and other publications. Her work has received numerous honors, including the prestigious Daniel Housberg Wilderness Image Award from the Alaska Conservation Foundation, a Lowell Thomas Award from the Society of American Travel Writers Foundation, and the Voice of the Wild Award from the Alaska Wilderness League. She is also the recipient of a Philip Hyde Grant Award for her work in the Tongass National Forest of Alaska and a Mission Award, both presented by the North American Nature Photography Association.*

Her book, Salmon in the Trees: Life in Alaska's Tongass Rain Forest *is the winner of an Independent Publisher Book Award and two Nautilus Book Awards. See http://www.salmoninthetrees.org. Her newest book,* The Salmon Way: An Alaska State of Mind, *has drawn numerous accolades. Intrigued that there is still a place in the world where the lives of people and wild salmon are inextricably linked, Amy ventured to Alaska to explore the web of human relationships that revolve around these extraordinary fish. Commercial fishermen took her on as crew; Alaska Native families taught her the art of preserving fish and culture; and sport fishing guides showed her where to cast her line as well as her mind. Alaskans everywhere, regardless of their wildly different beliefs, shared their salmon riches with her in their kitchens, cabins, and fish camps—it's the salmon way. The Salmon Way is a beautiful*

Amy Gulick. Photo credit: Amy Gulick.

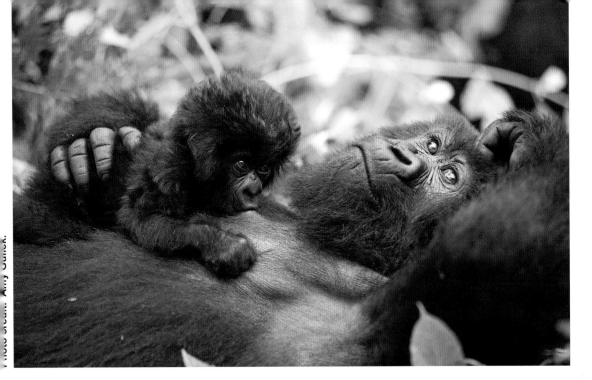

and enduring portrayal of people connect-ed to each other through the fish that define their lives.

Amy is a member of the Society of Environmental Journalists and is a founding Fellow of the International League of Conservation Photographers. View her work at http://www.amygulick.com.

What is your definition of conservation photography?

Conservation photography is the practice of making images that are used to raise awareness about conservation issues with the goal of moving people to take action.

How did you become involved in photography, and when did you become involved in conservation?

"As a kid, I was fascinated with both nature and storytelling. Before I could read or write, I would draw pictures to illustrate my stories. One day, I took my dad's Kodak pocket camera for a spin, and from then on, the camera became my tool of choice for illustrating my stories. I have an activist personality—my first letter to the editor was published at age 10. I marched in a sea turtle costume to protest international trade policies harming wildlife. I regularly attend public hearings and testify in support of clean air and water, and our public lands. It follows that my published stories focus on raising awareness about the natural world and its significance to humanity and all life on Earth."

What distinguishes conservation photography from ordinary nature photography?

"The big difference is what happens *after* the images are made. In conservation photography, the real work begins after the shutter is pressed. We use our images to raise awareness, shape public opinion, and influence decisions that affect conservation issues. Most ordinary nature photographs are not made with these goals in mind."

Why should other photographers become involved in conservation?
"The obvious answer is to ensure they will always have subjects to photograph! Without wild places and wildlife, we wouldn't be able to pursue our passion of photographing natural landscapes and their inhabitants. I also believe we have a bigger responsibility to act as stewards for the lands and critters we love to photograph. We are out there experiencing magical moments. Who better than us to advocate for the preservation of nature?"

In my book, I talk about photographing the good, the bad, and the ugly. How do you approach a theme or project you are working on with these things in mind?
"My approach has changed over the years. I used to think that if we showed viewers the threats and negative impacts to a place or species, it would follow that they would take action to stop the harm, but I have learned that there is a fine line between getting people's attention with negative images and overwhelming them to the point where they just tune out. My approach now is to make people fall in love with a place/species first, and then introduce the potential threats/harm. This involves showing a lot of beautiful, moving images and just a handful of 'ugly' ones. If people don't care about something first, then they won't be moved to take action regardless of how shocking and ugly the images may be."

Do you think a good "ugly" photo has as much impact as a pleasing nature image?
"A good 'ugly' photograph can have tremendous impact, but it will affect the viewer differently than a pleasing image. A beautiful image evokes feelings of joy and wonder; these photos should be used heavily to help viewers fall in love with a place or species. It is only after viewers feel that they have come to know a subject and care about it that the 'ugly' photos have a chance of having an impact. When used properly, the 'ugly' photos should evoke feelings of sadness and rage in viewers who feel the place or species they now care about is being harmed."

Have you taken many "ugly" photos?
"I have photographed my fair share of industrial-scale clear-cut logging in the coastal temperate rain forests of the Pacific northwest and Alaska. The sheer scale of this type of logging and the resulting damage to wildlife, streams, and people can be irreparable. Because much of this happens away from most people's eyes, I feel a responsibility to inform the broader public about what are clearly unsustainable logging practices. There are better ways to harvest timber, and we should be employing those. I have used my clear-cut photos in my public presentations featuring my book, *Salmon in the Trees.*"

Susan Sontag wrote, "Nobody ever discovered ugliness through photographs. But many, through photographs, have discovered beauty." Any thoughts on this?
"There are obvious 'beauty' shots—colorful pleasing sunsets, sparkling waterscapes, cute baby animals, etc.—but I also think that beauty can be discovered in a stark landscape or in a close-up image of an iridescent beetle eye or the striking pattern of snake skin—subjects that most people may not consider beautiful. It's our job to find

and illustrate our subjects so that viewers can discover beauty in new ways. As for 'discovering' ugliness, Sontag is right. There are universal themes of ugliness and we know them when we see them—harm, suffering, destruction.'"

What thoughts do you have about your approach to a theme or project you are photographing? Do you consider the lighting and mood differently when photographing the ugly (pollution, damage, etc.) over photographing the beauty of a scene? How? In what way? For example, harsh, midday lighting can emphasize the starkness of clear-cut logging; on the other hand, dark and overcast lighting can impart a sense of gloom.

"I have certainly seen devastating, ugly photos shot in the most pleasing light conditions—a shocking clearcut in gorgeous morning light. These don't work for me. Lighting creates mood, and if you're trying to evoke a sense of sadness or rage, then don't shoot ugly photos in pleasing light. It's too confusing for the viewer, who may perceive the gravity of the scene as being 'not so bad' because of the conflicting feelings of joy and wonder that the lighting evokes. If you're photographing an ugly scene, then it makes sense to pair it with ugly lighting—stark, gloomy, etc., to have the maximum impact."

Certain photographs have great shock value. Many years ago, on assignment for **Audubon** *magazine in East Africa, I photographed a dead rhino with its horns cut off. I used an ultra-wide angle lens up close to show the bloody stump along with the full body of the animal. The editor was concerned that the image was too shocking and graphic. Any thoughts?*

"If the goal is to move people to take action regarding an urgent situation, a shocking graphic can certainly spur people to act, but only if they first care about the subject. I think two photographs paired together—one endearing, one shocking—can serve both purposes, but it also depends on the audience. People well-versed in conservation issues generally already care, and the shocking image may be all they need to step up and take action. A broader audience may need to ease into the topic first before being hit with the shocking photo.

"There are other factors at work here, too. If an organization's goal is to retain and increase its membership to achieve conservation goals, they may run the risk of offending, alienating, or overwhelming viewers with shocking images. This can be tricky. In the end, I think photographers have to show the truth, no matter how ugly it may be, and the better conservation organizations aren't afraid to show the truth to its viewers. The truth hurts, no doubt about it. We may lose viewers, but we may gain viewers who are more likely to be engaged and take action on conservation issues."

What tips and tricks or techniques can you recommend?

"Get out there and shoot what you're passionate about. Even though we may focus on wild places and wildlife, don't forget that there's only one species viewing our images. Help audiences understand why the subjects you photograph are relevant to humanity. Tell stories about people affected by your subjects. See and show the big picture!"

What about involvement with conservation organizations? Thoughts? What about sending your photos to congresspersons or senators to influence legislation?

"It is crucial that we collaborate with conservation organizations. Our photos alone may inspire people to act, but without the follow-through of organizations working for many years to achieve conservation outcomes, we lack the capacity to pass legislation, establish protected areas, list endangered species, etc. I liken a successful working relationship with a conservation organization to Humphrey Bogart's great line from the movie, *Casablanca,* 'I think this is the beginning of a beautiful friendship.' We can be the go-to for all things visual and strengthen the communications of organizations. When it works, it's a beautiful thing."

Current projects? Future projects? Ongoing projects?

"My ongoing project is *Salmon in the Tree*s. The Tongass National Forest contains one-third of the world's rare old-growth coastal temperate rain forests. The issue is, do we continue to carve up this still-intact and remarkable ecosystem to the point where it no longer functions for the benefit of both people and wildlife? Since the dawn of time, man has always looked to nature to provide basic survival needs. Since the Industrial Revolution, though, we've looked to nature as a place to take from without really understanding the consequences of large-scale resource extraction and without understanding how we benefit from functioning ecosystems. There is a lot of hope in the Tongass because there is still time to get it right, and

we know it's the right thing to do. It has been very gratifying to work in this part of the world and help people understand what makes it so special and worth preserving."

Thoughts about the International League of Conservation Photographers? Why are you a member?

"Conservation photography can be a solo effort, which I enjoy, but coming together with colleagues from all over the world to collaborate and use our work to advance conservation on a global scale will accomplish more than each of us can do alone. Being a part of this passionate organization is inspiring and empowering. I am heartened to know there are others doing this critical work, and my fellow photographers motivate me to continue my own work and push the boundaries of what's possible."

I'm curious: how did your book* Salmon in the Trees *get its title?

"The book gets its title from the remarkable connection between salmon and trees in Alaska's Tongass National Forest. Salmon are born in freshwater streams and rivers. They head out to the ocean to mature, and then return to their birth streams to spawn the next generation. This part of the world boasts one of the highest densities of both brown and black bears due in part to an abundance of wild salmon in nearly 5,000 spawning streams. Bears catch great quantities of salmon and spread the carcasses throughout the forest. Over time, the nutrients from the salmon decompose into the soil, and the trees absorb this rich fish fertilizer through their toots. Scientists have actually traced a marine nitrogen, called nitrogen 15, *in* trees near

salmon streams that link directly back to the fish. So, ocean nutrients—brought by salmon, delivered by bears, and absorbed by plants—link the land and the sea."

Alison M. Jones

Alison M. Jones is an award-winning photographer with an honorary masters degree in photography from Brooks Institute of Photography. She is a senior fellow of the International League of Conservation Photographers and International League of Conservation Writers; she is also a member of the Society of Environmental Journalists, the National Arts Club, Tewksbury Land Trust Board (NJ), and Society of Woman Geographers. A former board director of the North American Nature Photography Association, she also chaired its awards committee. As Founding Director of No Water No Life ® (NWNL), Alison has led 70 documentary watershed expeditions since 2007, mostly to Africa and North America. Expedition photos and interviews (partly funded by a Philip Hyde Grant) are shared via the NWNL website, lectures, exhibits, blogs, articles, and an upcoming book. With a focus on youth, the NWNL exposes freshwater threats and promotes ecosystem management solutions.

Alison's work has been in BBC Wildlife, O: The Oprah Magazine, Esquire, Gourmet, Photographers Forum, *and other magazines, newspapers, books, annual reports, and calendars. Her nonprofit clients include Direct Relief, LightHawk, Techno Serve, The Mara Conservancy, AmerCares, and Save the Children.*

How and why I got into conservation photography.

"My vision of combining photography and conservation came from a fascination with nature, science, my early experiences in conservation, and lessons of history and indigenous cultures reflecting our ancient selves. No community has survived without a dependable source of pure water. When we muddy the well, we impede our own progress. Thus, I photograph to expose the destructive results of denial, greed, and 'short term-ism,' as I watch gains achieved by manipulating nature threaten our natural resources. Each one of us has the responsibility to stop those actions that muddy our planet so that our waters can run clear and freely for our own long-term benefit.

"My interest in conservation photography began in 1985 when I connected with Africa's open space. I experienced wildlife roaming in coordinated step with the Maasai, migratory birds, and the dramatic Rift Valley, 'the cradle of humankind.' I became a professional photographer with my images

Alison M. Jones. Photo credit: Alison Jones.

of East Africa's wildlife, but I didn't know enough about species' behavior patterns, predator/prey relationships, or the quality of light. I returned to coastal Connecticut to study photography, focusing on busy marinas, sunsets behind lighthouses, and changing light mirrored by the water.

"The African continent as a whole has been my photographic muse. I don't think it's possible to visit Africa for three decades and stay the same. I learned how many Western efforts to help Africa have only caused further problems. I learned that the African people, not western NGOs, are the key to saving Africa's heritage. Thus, I started photographing for East and West African NGOs fighting poverty and disease, threatened resources, and biodiversity. I lived in rural villages of Africa. I saw that a simple foot pump could allow a rural farmer to irrigate dry-season crops and thus triple his income.

"Kenyan friends asked me to join in the establishment of Kenya's Mara Conservancy—a community-based model of conservation in the Maasai Mara Game Reserve's 'triangle,' where over 2 million animals migrate from Tanzania's Serengeti Plains to the Mara River. Income from tourism witnessing this annual march of biodiversity supports 12 million Kenyans and Tanzanians. The conservancy's transparent management, serving Maasai landowners, is a model that many are now copying.

"Copiloting a Cessna over 2000 miles of Africa's waterways for three seasons, I photographed sub-Sahara Africa's ubiquitous design of lush green ribbons of rivers and lakeshores, strewn randomly over an otherwise dull-brown continent.

"That low aerial prospective provided a great '*aha!* moment.' I said in awe, 'It's so obvious! Where there's no water, there's no life.' I had the title for a project—I just didn't know how it would take shape, or that it would take up over eight years of my life. I only knew I wanted to document how water affects us and we affect water.

"I kept noticing our human footprint: watersheds being deforested and lakes disappearing. Lake Chad is $1/20$ of its 1970s size. Kenya has lost 50 percent of its forests in the last 25 years. Suffering faces I've photographed haunted me. I could no longer be a voyeur enjoying beauty while wilderness disappeared and people struggled.

"The ILCP network of scientists, conservationists, and photographers was a great source of encouragement. I trusted that NWNL imagery could bridge the gaps between North American ecologists and nomadic goat herders, between British Columbia and an African village. Illustrating the threads that connect us can help protect the resources that sustain us.

"NWNL has spent eight years gathering over 100,000 still images and over 400 Voices of the River interviews during its 22 watershed expeditions. All of this material supports the theory that the water story is a people story and that 'Water is the driver of nature,' per Leonardo da Vinci. Three NWNL case-study watersheds are in North America (Columbia, Mississippi, and Raritan River basins), and three are in Northeastern Africa (Nile, Omo, and Mara River basins). The diversity of these watersheds provides useful comparisons between degradation and management solutions in developed and developing worlds. The issues

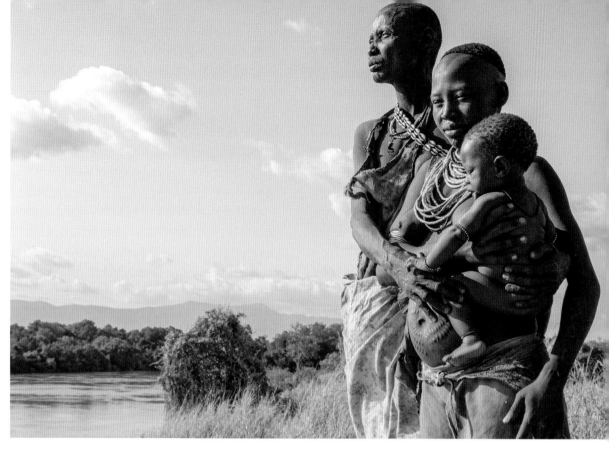

top. Ethiopia, Lower Omo River basin, Kotrouru, a Kwego village. Three generations of Kwego women on Ethiopia's Omo River as their river access was being appropriated. Photo Credit: Alison M. Jones for NoWater-NoLife.org.

above. Coal barge in Mississippi River spilling coal. Photo Credit: Alison M. Jones for NoWater-NoLife.org.

right. Kenya's Mau Forest, now decimated log by log, no longer retains rains needed downstream for the Mara River, the life blood of the Serengeti ecosystem. Thanks to Alison M. Jones, the Mau forest is now being restored and logging halted.

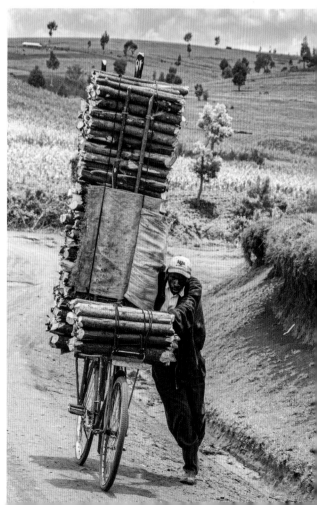

in these watersheds allow NWNL to fulfill its mission to raise upstream–downstream awareness of the vulnerability of our watersheds and to motivate global watershed stewardship.

"Conservation photography will always be relevant, since no place or species is protected in perpetuity, especially as our climate changes and populations explode. To be a conservation photographer means to be determined and committed with a personality of intention, yet open-minded enough to interest as many folks possible. Resilience and calm is needed to weather the horrors that must be documented, and an inner stability is needed to stay on keel and proactive amidst scenes of doom and gloom. Conservation photographers must collaborate with colleagues and other partners to strengthen their resolve, understanding of issues, and outreach. We must be willing to share and to turn over our work to the next generation. We are on a quest for harmony between humankind and nature, which sometimes leaves me feeling like the woman of La Mancha tilting at windmills. Thankfully, ILCP exists to support its Fellows while creating a repository of what Susan Sontag calls 'an ecology of images.' The successes of ILCP Fellows support my belief that stewardship is part of human nature.

"Conservation offers a clarity and focus that motivates one's photography, since it demands more attention to subject matter and final image. One stretches to capture and share more than just beauty, great light, and interesting compositions. One's skills improve when absorbed with a passion for creating the most impactful image possible. Conservation offers a fourth dimension to a photographer's life, and once that's discovered and your photographs matter, you are never the same."

Bob Rozinski & Wendy Shattil

I am sad to report that while the first edition of this book was in its final printing stages, my dear friend Bob Rozinski passed away, succumbing to his fight with cancer. Bob was truly a force in the conservation community and will be sorely missed for his tireless passion, dedication, and work on behalf of our planet, and especially the American West that he loved so much. His loving partner, Wendy, agreed that I should keep Bob's contribution here without change—a tribute to his fine work.

For more than three decades, Bob traveled North America and beyond to photograph wildlife and the outdoors. He and Wendy are among the rarest of species: full-time professional nature photographers, with specialties including endangered wildlife and fragile habitats.

Bob has been recognized frequently for his unique and evocative images. Along with partner, Wendy Shattil, Bob's other awards and recognitions include the Philip Hyde Grant for Environmental Photography, Environmental Stewardship Award from Denver Audubon, Outstanding Conservationist and Outstanding Business Partner of the Year from the Colorado Wildlife Federation, and induction into the NANPA Fellowship. They also won the Grand Prize in the Texas Valley Land Fund contest.

Bob and Wendy are Fellows in the International League of Conservation Photographers. They lead a limited number of photography trips, including Conservation

in Focus workshops devoted to teaching people to tell conservation stories with a camera. Wendy and Bob have produced 15 books, including the new edition of Valley of the Dunes, *and their photographs appear in virtually all nature and conservation magazines, including* National Wildlife, Audubon, Smithsonian, BBC Wildlife, Natural History, Ranger Rick, *and* National Geographic.

Wendy was the first woman to win Grand Prize in the BBC Wildlife Photographer of the Year competition. Other awards and recognitions include the Philip Hyde Grant for Environmental Photography (North American Nature Photography Assn.), Environmental Stewardship Award from Denver Audubon, Outstanding Conservationist and Outstanding Business Partner of the Year from the Colorado Wildlife Federation, the NANPA Outstanding Service Award, and induction into the NANPA Fellowship. Together, Bob and Wendy won the Grand Prize in the Texas Valley Land Fund contest.

What is conservation photography?

"Conservation photography involves images that convey an issue or concern involving the environment.

"Photographers are in places of environmental concern, and the rest of the public is somewhat removed from first-hand experiences in the natural world. The fact that we can illustrate things that people won't encounter themselves is very important. The way a conservation story is presented causes people to take action or have distinct opinions on issues and ways to protect the environment."

Bob Rozinski. Photo credit: Wendy Shattil.

Wendy Shattil. Photo credit: Wendy Shattil.

How did you become involved in photography, and when did you become involved in conservation?

"We were each involved in photography for many years before we met and started photographing as a team in 1981. We tackled conservation subjects before we knew that it was called conservation photography. We had a strong interest in endangered species such as whooping cranes, and spent a lot of time and effort to create images and tell a story about them.

left. Mule deer in the Rocky Mountain Arsenal National Wildlife Refuge in Colorado; the Denver skyline and mountains in the background. The work of Bob Rozinski and Wendy Shattil help get this area established as a National Wildlife Refuge. Photo credit: Wendy Shattil/Bob Rozinski.

right. Wendy documenting the impact of the partially completed wall on the Mexico border. Photo credit: Bob Rozinski.

In particular, we spent time photographing the Fish & Wildlife Service's attempt to establish a second migrating population of whoopers by using wild greater sandhill cranes as surrogate parents.

"We became formally involved in conservation photography when we were hired by the Department of Justice in 1988 to document wildlife at Rocky Mountain Arsenal, located at the edge of Denver. The World War II nerve gas manufacturing site was said to include the "most toxic square mile on earth" and was designated as one of the first EPA superfund sites.

"Our images were used to familiarize the public and Congress with the Arsenal, since it had been an unknown entity during its existence to date. The photos exhibited the value of the arsenal as open space and wildlife habitat. Photos we created over seven years of documentation were part of the materials provided to Congress as they determined the fate of the 27-square-mile property.

"Two years after we started photographing at the Arsenal, I had the privilege of receiving the Grand Prize in the Wildlife Photographer of the Year competition. The benefit of attending the awards ceremony in London and the opportunity to talk with accomplished photographers from all over the world made me recognize the powerful influence of images when the environment was concerned. The experience clarified our purpose to continue our photographic focus on conservation stories.

What distinguishes conservation photography from ordinary nature photography?
"Conservation photography looks for all aspects of the story: the good, bad and the ugly. It's a photojournalistic approach. Most people photograph the natural world for personal enjoyment. Conservation photography is a purposeful act to enlighten others about an environmental issue, looking for nuances probably not considered otherwise."

Why should other photographers become involved in conservation?
"Photographers at any level are capable of bringing about change and awareness of conservation issues. They don't have to be *National Geographic* photographers. It just takes someone with the passion,

knowledge, concern, and a camera to make people aware of a subject and a particular problem.

"In 1988, we started a photography club for the sole purpose of creating a book on urban wildlife *(Close to Home: Colorado's Urban Wildlife* [1990]). We instructed people on how to tell a story and shoot for publication. We also brought in experts on wildlife subjects the photographers might encounter in our urban areas. One of the 200 people who joined the Urban Wildlife photo club was a woman named Bini Abbot who lives in Arvada, a suburb of Denver. Bini enjoyed visiting a wetland near her house called Two Ponds. When she heard it was going to be developed into a residential housing project, she took her camera to Two Ponds and photographed great blue herons, foxes, owls, habitat, and everything else associated with the space. Bini was the first person to say that she was a terrible photographer, yet it didn't matter, because along with her snapshots, she passionately introduced people to Two Ponds and what was at risk. Her plea was forceful and effective. Bini took the images and her passion to the city council of Arvada, and they recognized the concern. She also made a presentation to the Army Corps of Engineers and through her efforts, Two Ponds is now a National Wildlife Urban Refuge.

"Starting a project, we evaluate the situation. In advance of photographing, we identify the issues and create an image list that could illustrate the good, the bad, and the ugly. We research groups and individuals already knowledgeable on the subject, then decide specifically what and where to photograph. It's important to also be flexible about aspects that present themselves that weren't initially on our radar.

"It's best to reach the broadest audience possible with a conservation issue. Initially, alienating people on the other side of the topic is to be avoided. When you are even-handed in telling a story, you can hopefully engage people on all sides, rather than antagonize them."

Do you approach projects with different mood or lighting when photographing the ugly as opposed to the beautiful?

"Regardless of what we're shooting, we want images to have the greatest possible impact, whether it's positive or negative. We just want to create the optimal image."

What tips, tricks, and techniques can you recommend?

"If a situation is unfolding, capture it as well as possible. You also want to make the content meaningful. The more you photograph, the more comfortable you become with a camera. Knowing what your camera

sees makes the image capture more natural. You don't want to miss the opportunity because you didn't recognize it or miss the photo because you just didn't have the expertise to capture it. Photographing regularly, becoming familiar with what you're doing and why you're doing it, is very important.

"In addition to overall camera skills, look for viewpoints beyond the usual perspective. We like to utilize aerial photography for the added frame of reference. Some of Wendy's strongest images of the border wall in Texas are aerials that put the issues in perspective. They show the extent of environmental disruption on both sides of the wall and the severing of wildlife corridors. The aerial views are powerful because they provide context. Supporting organizations like LightHawk, which provides planes and pilots for conservation purposes, are outstanding examples of people who help us create that next level of imagery."

What about involvement with conservation organizations or trying to influence politicians and legislation?

"Conservation organizations can benefit from photography, but they don't always have a budget. It helps to find creative ways to work with them, particularly if you're in a position to have to make a living from your photos. Some benefits may not be in the form of dollars, but rather access or visibility through the organization. Conservation groups welcome images that further their goals. Connecting with politicians is a challenge because they're inundated from so many directions. That's another advantage to being involved with conservation organizations. They have name recognition and sometimes lobbyists or other means to rise above an individual's ability to connect with those decision-makers.

"When Great Sand Dunes was on the path to elevate its status from a monument to a national park, some of our own efforts through The Nature Conservancy brought our images in front of the congressional appropriations committee. Whether or not they influenced the decision, we're not absolutely sure, but we were able to add compelling visuals to the information base.

Wendy continues to document the effects of the border wall on wildlife and the environment. She's also working on their second book about the Rocky Mountain arsenal, which will tell the 25-year story of evolution from an EPA Superfund site to the National Wildlife Refuge it has become today.

Wendy is managing editor and photo editor of Cloud Ridge Publishing, a non-profit conservation-based book publisher. Recent books include the award-winning multi-photographer books, *The Salish Sea: Jewel of the Pacific Northwest* and 2020 release of *Pacific Flyway: Waterbird Migration from the Arctic to Tierra del Fuego.*

Bob passed away in 2016, and Wendy continues to pursue the projects and goals the team shared for 36 years.

Onward!

""Seeing the world through this particular lens has made my own life so much more meaningful and rich."—Morgan Heim, conservation photographer

Is it all worthwhile? What are the rewards? To answer those questions, you have to examine your own photographic philosophy and how you feel about the natural world. You can, of course, continue photographing wildlife and beautiful landscapes without joining the battle to save these things. After all, there is a lot of work involved in conservation photography. But there are some rewards. Having direction and purpose to your photography can help you develop skills that will benefit your work, perhaps even leading to publication and new horizons. Should you hope to become a professional, earning a living at it, these skills will be vital. Beyond any future monetary rewards, there is the pleasure of knowing that your work has aided in preserving and protecting places and species that are becoming scarce in our world.

A few years ago, I returned to make another whitewater raft trip on the Snake River in Hells Canyon. With me were a few Idaho friends. The rest of our party was made up of other folks from various parts of the country. None of the others in the group had been to Hells Canyon before, and I hadn't been back since the 1972 trip with Pete Seeger. It was refreshing to see that the canyon was as beautiful as I remembered it from my early photographs.

right. **Mountain goat and young.**

For the next six days, we floated downriver through magnificent scenery that, if the dam had been built, would all be under hundreds of feet of water.

On our first day on the river, we ran two of the major rapids: Wildsheep and Granite Creek. There was that surge of adrenaline as we plunged into massive waves, getting refreshingly drenched by the cold waters.

After the Granite Creek rapids, we slipped along on quiet waters, drifting with the current and taking in the lush green hillsides splashed with wildflowers. At the base of one dark, towering wall, a mountain goat and her two youngsters grazed peacefully. No one spoke for a long while, then two of the rafts maneuvered closer to mine. In a chorus, the people in them shouted, "Thank you, Boyd!"

I was dumbfounded. What on earth were they thanking me for? A few made sweeping gestures with their hands, pointing up toward the canyon walls. Then it dawned on me: my Idaho friends had told the others of my involvement in saving this place, stopping the proposed dam, and getting

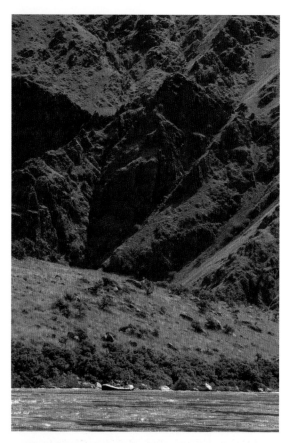

top. We drifted on.

bottom. The raft almost flipped when hit by a lateral wave in Hells Canyon. It didn't but two of us got tossed out (one already under the white wave and me in blue parka going over). Photographer Amy Gulick, feet in the air, almost went overboard. Photo credit: Kendrick Moholt.

protective legislation passed. Wow. I have to admit I got choked up. Their gratitude, expressed in the midst of this wild beauty, was ample reward for the years of hard work it took to save the place. We drifted on, absorbing and enjoying it all.

Addendum

In 2017, I returned yet again for a raft trip in Hells Canyon, this one for a celebration of the 50th anniversary of when several of us founded the Hells Canyon Preservation Council. It was a very festive occasion, and later, there was to be even more celebration in Portland with my old friend, retired former U.S. Senator from Oregon Bob Packwood.

This raft trip turned out to be something quite different from my previous ones. In the past, the river flow for my trips averaged about 20–25,000 cubic feet per second. Due to extra heavy winter snow in the mountains nearby, the river on this trip was a raging 55,000 cubic feet per second, and only days earlier, it had been over 70,000 cubic feet per second. That meant that the two class IV rapids were now class V, the top of the scale.

We were but 15 minutes into our five-day trip when our raft was hit by a lateral wave, lifting the side so high I thought we were going completely over. It didn't flip, but it was high enough to dump two of us overboard into the icy waters. On my way over, I must have hit part of the metal rowing frame. I broke a rib. For the remainder of the trip, I learned how painful it is to get into and out of a sleeping bag with a broken rib.

It didn't matter. It was so good to be back in this magnificent gorge with friends. Hells Canyon was as beautiful as it was 50 years ago when we almost lost it.

Resources

- **Baikal Watch**
 https://www.earthisland.org/index.php/project/entry/baikal-watch

- **Conservation International**
 www.conservation.org

- **Defenders of Wildlife**—www.defenders.org

- **Earth First**—www.earthfirstjournal.org

- **Earth Island Institute**—www.earthisland.org

- **Endangered Species Coalition**
 www.endangered.org

- **Environmental Defense Fund**—www.edf.org

- **Hells Canyon Preservation Council**
 www.hellscanyon.org

- **International League of Conservation Photographers**
 www.conservationphotographers.org

- **International League of Conservation Writers**—www.ilcwriters.org

- **Izaak Walton League**—www.iwla.org

- **League of Conservation Voters**
 www.lcv.org

- **National Audubon Society**
 www.audubon.org

- **National Geographic Society**
 www.nationalgeographic.com

- **National Wildlife Federation**—www.nwf.org

- **Natural Resources Defense Council**
 www.nrdc.org

- **Nature Conservancy**—www.nature.org

- **North American Nature Photography Association**—www.nanpa.org

- **No Water No Life**—www.nowater-nolife.org

- **Pacific Environment**
 www.pacificenvironment.org

- **Rainforest Action Network**—www.ran.org

- **Serengeti Watch**—www.savetheserengeti.org
- **Sierra Club**—www.sierraclub.org
- **Union of Concerned Scientists**
 www.ucsusa.org
- **WILD Foundation**—www.wild.org
- **Wilderness Society**—www.wilderness.org
- **World Wildlife Fund (WWF)**—www.wwf.org

If you are serious about using your photography for conservation, you may wish to visit the websites of the conservation photographers featured in this book. You can learn a lot from their great work!

- **Alison M. Jones**—www.NoWater-NoLife.org
- **Amy Gulick**—www.amygulick.com
- **Clay Bolt**—www.claybolt.photoshelter.com
- **Katherine Feng**
 https://conservationphotographers.org/profile/?uid=124
- **Ian Michler**—www.inventafrica.com
- **Joe Riis**—www.joeriis.com
- **Wendy Shattil**—www.dancingpelican.com
- **Dave Showalter**—www.daveshowalter.com
- **Scott Trageser**—www.naturestills.com
- **Jim & Cindy Griggs**
 www.selective-focus.com

Index

AmherstMedia.com

- New books every month
- Books on all photography subjects and specialties
- Learn from leading experts in every field
- Buy with Amazon (amazon.com), Barnes & Noble (barnesandnoble.com), and Indiebound (indiebound.com)
- Follow us on social media at: facebook.com/AmherstMediaInc, twitter.com/AmherstMedia, or www.instagram.com/amherstmediaphotobooks

Create Pro Quality Images
with Our iPhone Photography for Everybody Series

iPhone Photography for Everybody
Black & White Landscape Techniques

Gary Wagner delves into the art of creating breaktaking iPhone black & white landscape photos of seascapes, trees, beaches, and more. $29.95 list, 7x10, 128p, 180 color images, ISBN 978-1-68203-432-3.

iPhone Photography for Everybody
Artistic Techniques

Michael Fagans shows you how to expertly use your iPhone to capture the people, places, and meaningful things that color your world. $29.95 list, 7x10, 128p, 180 color images, ISBN 978-1-68203-432-3.

iPhone Photography for Everybody
Family Portrait Techniques

Neal Urban shows you what it takes to create personality-filled, professional-quality iPhone family portraits. $29.95 list, 7x10, 128p, 180 color images, ISBN 978-1-68203-436-1.

iPhone Photography for Everybody
Landscape Techniques

Barbara A. Lynch-Johnt provides all of the skills you need to master landscape photography with any iPhone. *$29.95 list, 7x10, 128p, 160 color images, ISBN 978-1-68203-440-8.*

iPhone Photography for Everybody
Still Life Techniques

Beth Alesse provides creative strategies for artfully photographing found objects, collectibles, natural elements, and more with an iPhone. $29.95 list, 7x10, 128p, 160 color images, ISBN 978-1-68203-444-6.

iPhone Photography for Everybody
App Techniques—Before & After

Paul J. Toussaint shows you how to transform your iPhone photos into fine art using an array of free and low-cost, simple apps. $29.95 list, 7x10, 128p, 160 color images, ISBN 978-1-68203-451-4.